MAY 1991

Degas Pastels

Degas Pastels

by Anne F. Maheux

National Gallery of Canada
Ottawa, 1988

Canadian Cataloguing in Publication Data

Maheux, Anne F.
Degas pastels.

Issued also in French under title: Les pastels de Degas.
ISBN 0-88884-547-2
1. Degas, Edgar, 1834–1917. 2. Pastel drawing.
I. National Gallery of Canada. II. Title.

ND553 D43 A4 1988 759.4

C-88-099500-9

Available from your local bookseller or The Bookstore, National Gallery of Canada, Ottawa K1A 0M8

Cover illustration: Detail from *Racehorses*, 1895–1900 (fig. 30)

Design: Eiko Emori

Printed in Canada

Contents

Foreword

In its broad mandate to develop, to preserve, and to study its collections, the National Gallery of Canada has traditionally mounted exhibitions. Such exhibitions contribute to an examination and greater understanding of the Gallery's own collections.

In any exhibition, the preservation of the objects borrowed is a matter of the greatest concern. With *Degas*, what began as an exercise in determining how to responsibly care for these fragile works on paper, became an opportunity for two of the graphic arts conservators, Anne Maheux and Peter Zegers, to research the particularly complex nature of this artist's work in pastel.

They began by studying the three Degas pastels and one charcoal drawing in the Gallery's collection; and then went on to examine his pastels in other public and private collections. They consulted artists' treatises and visited workshops of pastel manufacturers in France, some of which were active in Degas's day. Anne Maheux reports on the results of their research in this book.

Modern methods of investigation, such as infrared spectroscopy and polarized light microscopy, may appear daunting to the nonspecialist. Yet, the results of this research, when made available in such an attractive format as the present volume, are likely to fascinate and to inform the general public. The analysis of works of art contributes to the advancement of scientific knowledge about the materials and techniques of the artist. Layer-by-layer, this analysis reveals the workings af Degas's mind and imagination.

Dr. Shirley L. Thomson
Director, National Gallery of Canada

6

Preface

In 1983 the National Gallery of Canada initiated the idea of a Degas retrospective exhibition – to be mounted in conjunction with the Réunion des musées nationaux, Paris, and the Metropolitan Museum of Art, New York. Realizing that at least fifty percent of Degas's œuvre consists of works incorporating pastel, and that this significant proportion of his work has never been thoroughly studied, the National Gallery asked its graphic arts conservators to undertake an in-depth research project on Degas's work in pastel and related media.

The main objective of our research has been twofold: to determine how Degas used pastel and to study why the medium appealed to him. It was hoped, too, that a systematic study of the materials and technical construction of the pastels might shed light on two problematic aspects of Degas's œuvre: dating Degas's works, and determining the degree of "finish" of a given work. Finally, we hoped to clarify Degas's position as a *pastelliste* in the context of French artists who worked with the medium in the second half of the nineteenth century.

On a more practical level, the research team aimed, through close examination, to gather information on a large number of pastels by Degas in public and private collections. The preliminary findings of the Degas Pastel Research Project were reported by Anne Maheux and Peter Zegers in the *AIC Preprints* (American Institute for Conservation of Historic and Artistic Works: Chicago, 1986). The information on pastels then became an invaluable source for the authors of the exhibition catalogue, *Degas* (1988), accompanying the retrospective in Paris, Ottawa, and New York. To aid the reader in identifying works illustrated here that may also be in the exhibition,

bracketed reference numbers starting with "L" (from the catalogue raisonné by Paul-André Lemoisne) have been given wherever known.

A considerable body of literature has been reviewed, including eighteenth- and nineteenth-century treatises and manuals on the manufacture and application of pastels and fixatives, and commercial guides such as the *Annuaire-Almanach du Commerce*. These have supplied a wealth of information on pastel manufacturers and artists' suppliers and their products in Degas's Paris. We contacted existing French pastel manufacturers whose establishments date from the eighteenth and nineteenth centuries, such as Henri Roché, Girault, and Sennelier. Not only did these firms provide us with documentation on their respective establishments and products, but kindly allowed us to visit their workshops.

The most recent studies of the medium have been most informative.[1] We have also compiled observations on Degas's pastel technique found in the literature on the artist.

Finally, in the works reviewed, we have aimed to differentiate between the effects the artist intended and those that have resulted from the accidents of time. Facsimiles of pastels were produced to illustrate these changes and aid us in understanding the complex physical nature of Degas's preferred materials. This exercise familiarized us with Degas's process and particular use of pastel. The results have been assembled in a special pastel project installation to complement the major retrospective.

The pastels at the National Gallery of Canada have been a constant source of information. Because of the variety of pastel techniques, and stages of execution that they represent, we have been able to piece together the evolution of Degas's methods and materials.

Over the last three years, many people have most kindly made available the Degas pastels in their collections for our detailed examination. I am particularly indebted to all the curators, conservators, and owners of Degas pastels, who have gone to great lengths to accommodate our requests to examine the pastels out of their frames.

Peter Zegers and Douglas Druick, who have been actively involved in all stages of the project, must be thanked for their continued interest and encouragement.

To Jean Sutherland Boggs, I offer my thanks for graciously reading the manuscript on such short notice, and wish to acknowledge the assistance given by her staff in the Degas office.

I am also grateful to Peter Smith for his advice and constant support as the manuscript took shape, to Lynda Muir and Jacques Pichette, the editors at Publications Division, and to Charles Hupé of Photographic Services.

Anne F. Maheux

1

Pastel Painting before Degas

Pastel Painting to the Nineteenth Century

Among the many media encountered in the history of drawing, pastel has provided artists throughout the centuries with a diverse assortment of techniques, for a multiplicity of purposes.

Edgar Degas (1834–1917) developed a vocabulary of pastel techniques by bringing to this traditional medium a technical inventiveness that remains unequalled to this day. However, it is of interest to note that in the course of the history of pastel painting, one uncovers precursors to Degas's innovations, both in the works of early *pastellistes* and in the artists' instruction manuals and treatises, which have provided a rich source of descriptions of contemporary practices, including pastel manufacture, and procedures for fixing and protecting the delicate surface of the finished pastel painting.

From the beginnings of the use of pastel in the late fifteenth century, when Leonardo da Vinci first chronicles "the dry method of applying colour,"[2] the medium has been customarily employed as a secondary one: for embellishing black chalk drawings (typically portraits) and for executing preliminary studies for oil paintings, such as *The Presentation of the Virgin* (fig. 1), by Jacopo Bassano (1517–1592). By the seventeenth century, the advantages of working in pastel are more fully exploited. On one level, pastels were technically more straightforward to use than oils (this quality no doubt contributing to the great attraction they have always held for amateurs), yet they could be made to emulate and sometimes surpass the qualities achieved with oils, particularly in the portrayal of rich textural effects.

The height of this achievement is no better represented than in the beginning of the eighteenth century, when *l'age d'or du pastel* truly comes into its own, and culminates in the work of artists like

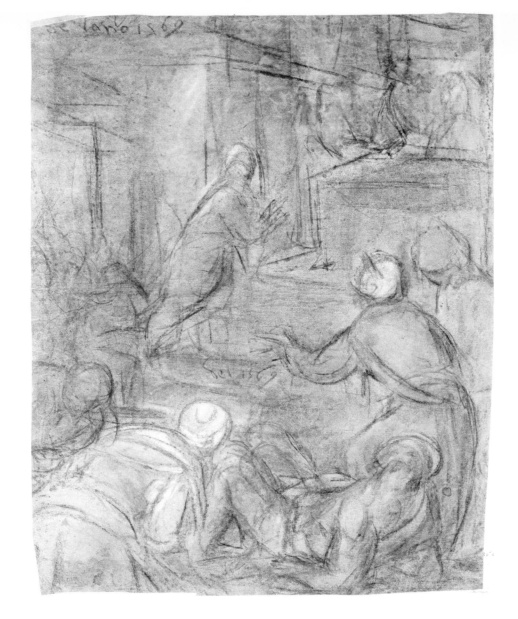

1
Jacopo Bassano
*Presentation of the
Virgin* 1569

Black, white, and
coloured chalk on
blue-grey laid paper
52 × 39.7 cm
National Gallery of
Canada (4431)

Rosalba Carriera (1675–1757), who is acknowledged to have popula-
rized the medium and encouraged its widespread adoption in Europe,
and particularly in France. Carriera's portrait *Countess Miari* (fig. 2)
exemplifies the vaporous, ephemeral quality associated with
eighteenth-century pastels. In her use of both wet and dry pastel
techniques, Rosalba could be seen as a prototype of Degas.

Given Carriera's example, it was then Maurice Quentin de La Tour
(1704–1788) who carried pastel to new heights (see fig. 3), becom-
ing the most prominent French artist working in the medium in the

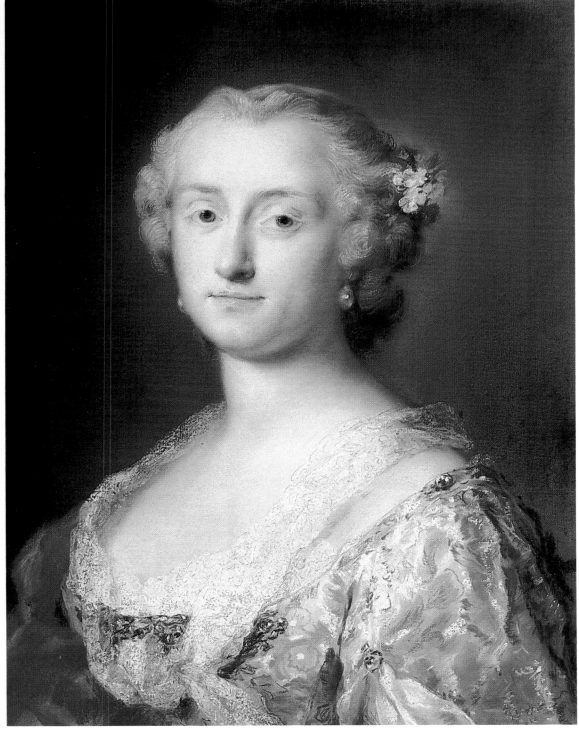

2
Rosalba Carriera
Countess Miari
1740–45

Pastel on blue laid
paper mounted on
canvas
52.6 × 40.5 cm
National Gallery of
Canada (23647)

3
Maurice Quentin de
La Tour
*Portrait of the
Marquise de
Pompadour* 1755

Pastel on blue-grey
paper mounted on
canvas
177.5 × 131 cm
Musée du Louvre,
Cabinet des Dessins
(27.614)

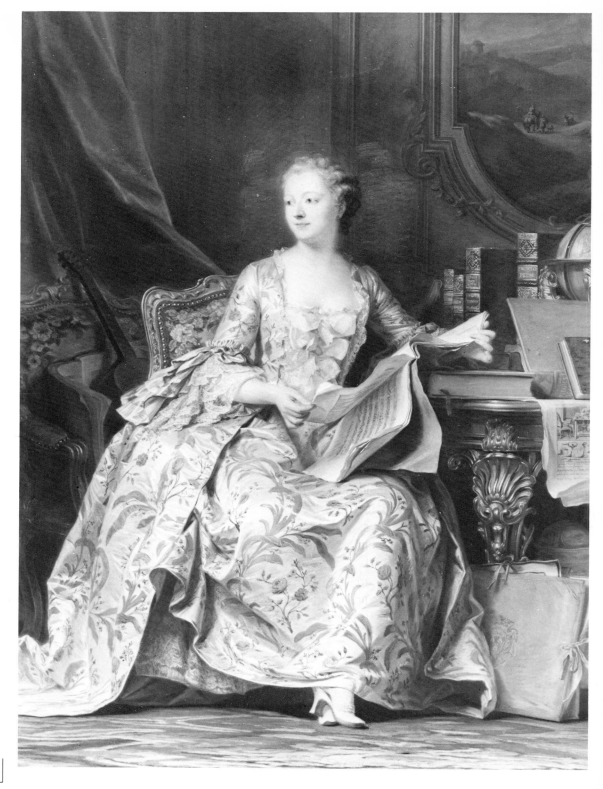

eighteenth century. Artists such as de La Tour were attracted to the brilliance and luminosity of pastels, which, unlike oil paints, do not have an inherent tendency to alter with time. However, problems of preservation – of finding a method of fixing the surface of the pastel without altering its fragile and velvety quality – have been of paramount concern from the outset. De La Tour was particularly plagued by the need to find an acceptable fixative. This was a passion that habitually preoccupied artists, and was later shared by Degas: for him, a fixative that would not detract from the matte, luminous quality that he sought with pastel was essential.[3]

De La Tour's rival, Jean-Baptiste Perronneau (1715–1783), is accredited as being one of the first true *coloristes* working in pastel.[4] Perronneau's unorthodox manner of laying in shadows with green hatchings signals not only Degas's development of "arbitrary" colour, but also his distinctive technique of building up pastel in zones of *hachures* – broad, parallel strokes of colour, sometimes applied in crisscrossing networks.

An even more direct comparison in technical handling to Degas can be drawn in the pastels of Jean-Baptiste Siméon Chardin (1699–1779), an artist who did not take up pastel until late in his career, and who, like Degas, had trouble seeing: "My infirmities prevented my continuing with oil-painting, so I fell back on pastel...."[5]

Chardin applies pastel in parallel hatchings of pure colour, modelling and simultaneously reconstructing form, relief, and light. His thick textures of superimposed layers of pastel are technical innovations that remain unrivalled until Degas[6] (see fig. 4). Chardin also marks a break with the artificiality of the eighteenth century so far; his works are more realistic, less affected than those of his contemporaries. Like Degas, he gravitates towards genre subjects.

Pastel loses momentum at the close of the eighteenth century, by which time it had come to be seen as an art form mirroring the voguish affectations of the *ancien régime*. As one critic later commented: "To capture this ephemeral era, painting itself had to become ephemeral...."[7]

4
Jean-Baptiste-Siméon
Chardin
*Self-Portrait with
Visor* c. 1776

Pastel on laid paper
mounted on canvas
45.7 × 37.8 cm
Art Institute of
Chicago, Clarence
Buckingham and
Harold Joachim
Memorial Fund,
Clarence Buckingham
Collection (1984.61)

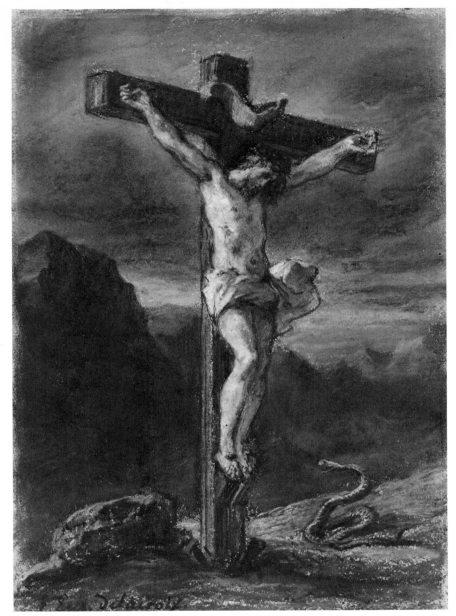

5
Eugène Delacroix
The Crucifixion
c. 1847

Pastel on blue-grey
paper
24.7 × 17 cm
National Gallery of
Canada (15733)

Although artists continue to sporadically use pastel into the
nineteenth century (see fig. 5), tentatively exploring the medium
for its potential in colouristic intensity, it is not until the medium
enjoys a popular comeback in his own lifetime that the stage is
truly set for the pastel accomplishments of Degas.

Though pastel was used by artists throughout the nineteenth century, examination of both the official "Salon" catalogues and contemporary literature leads to the conclusion that there were only two acknowledged revivals of interest in the medium: the first in the 1830s and the second in the 1880s.

A growing number of pastels were exhibited at the Salons of the early 1830s. In fact, for the first time in Salon history, pastels (and *aquarelles*) are acknowledged as a distinctly separate category.[8] A proliferation of technical treatises on pastel followed on the heels of renewed interest, in recognition of the virtues of the medium. These treatises underscored how pastel involved almost pure pigment with very little binder, how it was liberated from the inherent vices and unavoidable alterations associated with colours bound in oil. Despite efforts to extol its virtues, pastel enjoyed only short-lived favour, and attempts to shake off the stigma associated with *le divertissement des demoiselles de bonne maison* were not altogether successful.[9]

By the early 1860s the first revival had lost momentum, despite the rediscovery of and admiration for Rosalba Carriera and Maurice Quentin de La Tour in the mid-1850s.

Jean-François Millet made a significant contribution with his work in pastel, produced mainly after 1865.[10] His innovations, both stylistically and technically, no doubt won the admiration of Degas, who collected Millet's pastels. Like Chardin's, Millet's technique of parallel *hachures* in bright colours prefigures Degas (see fig. 6).

From 1874, there is an evident increase in the number of pastels (and gouaches) shown at the Salon. The pastel medium had undergone a general re-evaluation, resulting in a more widespread acceptance of the medium. By this time, Degas had already started to use pastel, for preliminary studies for paintings, for portraits, and for small landscape studies.[11]

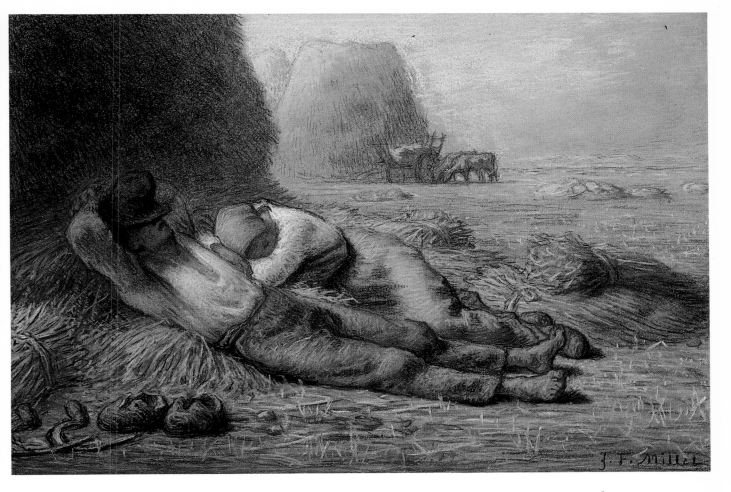

6
Jean-François Millet
Noonday Rest
c. 1866

Pastel and black
conté on buff wove
paper
41.3 × 52.5 cm
Boston Museum of
Fine Arts. Gift of
Quincy Adams Shaw
through Quincy A.
Shaw, Jr. and Mrs.
Marian Shaw
Haughton (17.1511)

19

2

Degas and Pastel

Degas began to work in pastel in the late 1850s and early 1860s. His early works are "classic" in every sense – from their subject matter to the technique in which they are executed. Initially Degas used pastel for preliminary sketches and studies (the small landscapes of 1869, for example). Eventually he adopted the medium and, returning to it in the 1880s, he used it almost exclusively from 1895 until the end of his career.

There were many factors contributing to Degas's initial attraction to pastel and other opaque media. Degas returned to Paris, after an extended visit with family in New Orleans, in the spring of 1873, with a driving ambition to make a new and significant contribution to the art of his time.[12] Pastel, gouache, distemper, used in conjunction with experiments in printmaking, begin to take the place of painting with oils. This was an extremely productive period for Degas; between his return and 1881 he executed approximately one-quarter of his known work, using a variety of media in an unprecedented spirit of experimentation. Pastel was to become his favourite; it accounts for more than seventy percent of his work in colour produced during these years.[13]

At this time, other artists working in pastel had no doubt attracted Degas's attention. We have already noted that Degas was familiar with the work of Millet; the collection of Millet's pastels, commissioned by the art collector Émile Gavet, was exhibited and sold in 1875. Fantin-Latour had begun his experiments with pastel over impressions of his lithographs (see fig. 7). The recent work in pastel by Degas's friend Giuseppe de Nittis was drawing much interest and public acclaim.[14]

It is also perhaps no coincidence that Degas employed the flat,

7
Henri Fantin-Latour
The Rest on the Flight into Egypt
1889

Pastel and watercolour over lithograph on wove paper, mounted on stretcher
55 × 46 cm
National Gallery of Canada (26647)

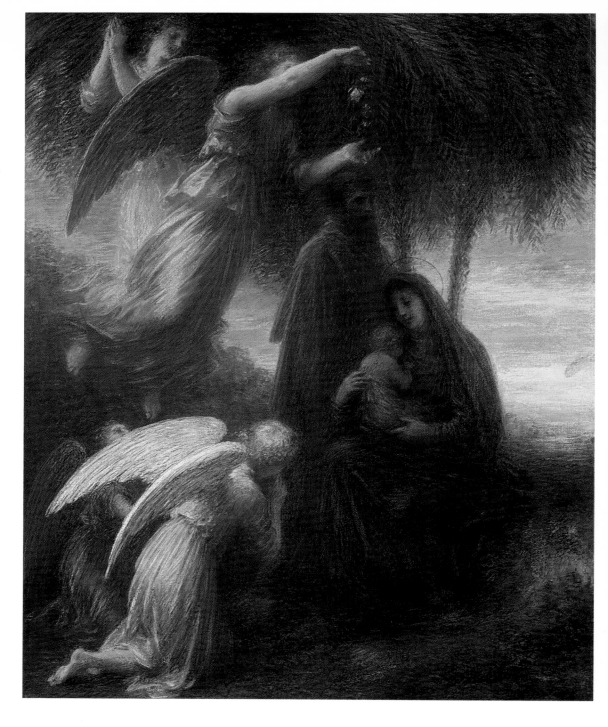

luminous colours of distemper (*peinture à la colle*), commonly used for painting sets and stage flats, in some of his own compositions devoted to the theatre. However, his attraction to this medium, and others like it, went deeper. Pastel, distemper, and gouache are media that possess optimum working properties for an artist like Degas, who was inclined to be constantly rethinking and reworking his compositions. They combined freedom of expression with ease of handling. But pastel, more so than the other opaque media, was direct. Unlike oil paint, it required little preparation and no drying time; it could be used spontaneously and work-in-progress would be resumed and abandoned at will. It had the great advantage of allowing the artist to change his mind with minimum penalty.

Because of these qualities, Degas could quickly realize small-scale works with pastel, gouache, and distemper that yielded ready income, and that could be marketed less expensively than paintings. These were no doubt important considerations for Degas in the mid-1870s, at a time when family financial troubles and the general economic depression necessarily affected his lifestyle.[15]

Perhaps above all, pastel served to unite drawing with colour. For Degas, drawing – as Ingres's example often reminded him – was the intrinsic base of his method of working. As Degas advised the young painter Jacques-Émile Blanche: "Make a drawing. Start it all over again, trace it. Start it and trace it again."[16] Degas was instrumental in demonstrating, for the Impressionists, the value of drawing – not only for its ability to capture spontaneity, but more importantly for its value as a tool for exploring stylistic problems and resolving compositional concerns. Lloyd and Thompson have noted the contribution of pastel in this context:

> *For the first time in the history of art, so it would seem, the aesthetics of painting and of drawing began to overlap. This new and significant development, allied to the use of broader techniques, such as coloured chalks and pastel, meant that the old arbitrary division between brush and pencil was gradually abandoned: the hierarchy of traditional values was finally eroded.*[17]

Degas's move to pastel may also be attributed in part to the acknowledgement of the growing complications of working with oil in the nineteenth century.[18] New generations of artists were unfamiliar with and unschooled in the traditional practical knowledge of oil-painting techniques. Problems inherent in paint manufacture, stemming from potentially deleterious additives, the given tendency of the oil binder to yellow over time, variations in the characteristics of commercially-prepared grounds, and the effect of the varnish layer – all these contributed to a growing multitude of variables that the artist had to deal with. Degas lamented the loss of technical expertise in his times: "This difficult trade of ours, the one we ply unwittingly ... these techniques that David knew, he who was student of Vien, dean of the Académie des Beaux-Arts, techniques forgotten by painters at the outset of the century."[19]

Degas's comment also points to the fact that he was interested in, even intrigued by the time-honoured methods and materials of the old masters. Pastel – given its illustrious stature in the eighteenth century, particularly in France – seduced Degas. He resurrected the medium and used it in boundless experimentation.[20]

In summary, Degas's sudden shift to the opaque media is attributable to concerns similar to those that led him to printmaking: fascination with the creative possibilities stimulated by recent discoveries, sensitivity to the expressive connotations of his materials, the possibility of financial gain, and a revisionist attitude towards the artistic media.[21]

3

Degas's Pastel Technique:
Evolution and Innovation

In total, Degas produced almost seven hundred works in pastel. His versatility in the medium is expansive, and has been typically categorized by technique – not only manipulation of the pastel itself but also the incorporation of other like media: gouache, distemper, and *peinture à l'essence*, which is produced by soaking the oil out of the paint then diluting it with turpentine.[22]

As we have already noted, the roots of Degas's pastel technique may be traced in part to methods developed by earlier artists who adopted the medium. Similarly, many of Degas's so-called innovations can be seen as conforming to practices advocated in both earlier and contemporary treatises.

Denis Rouart's *Degas à la recherche de sa technique* (1945) is the greatest source on Degas's methods and materials in all media. It especially provides a cornerstone for information and chronological context by which Degas's pastel technique can be charted and its evolution explored. In addition, the subject has prompted a number of more recent studies devoted to the pastels.[23] The detailed examination of a number of pastels out of their frames has been essential in allowing us to corroborate or disprove assertions by Rouart and other authors who claimed to have direct or at least second-hand information about the artist's habits.

Degas's method of initially smudging the strokes, or "sweetening" (the blending of pastel strokes to create seamless passages of colour), in early compositions – and later used as a device to establish volume and form in the preliminary charcoal drawings beneath his more highly developed pastels – was commonly em-

8
Degas
*Portrait of Mme
Edmondo Morbilli*
c. 1869

Pastel on paper
51 × 34 cm
Private collection
[L 255]

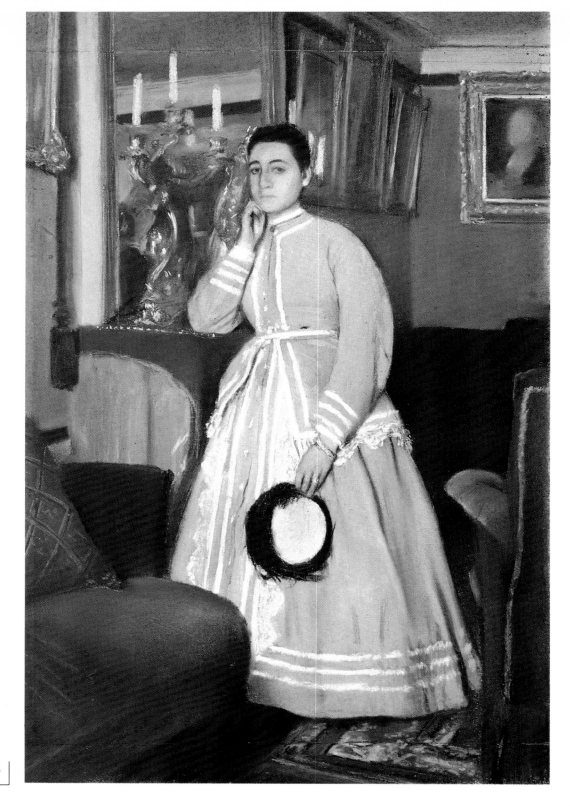

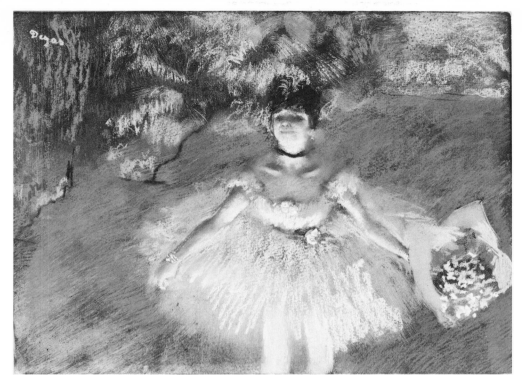

9
Degas
Dancer Onstage with a Bouquet 1878–80

Pastel over monotype
in black ink
27 × 38 cm
Private collection
[L 515]

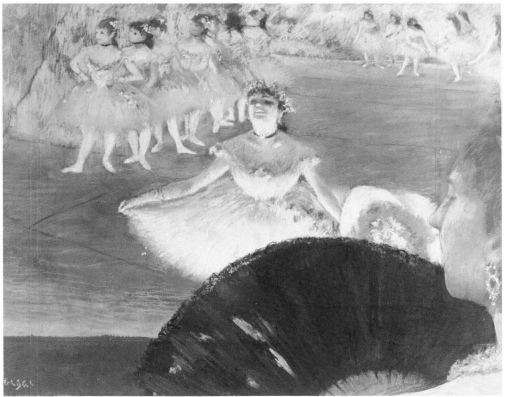

10
Degas
Dancer with Bouquet
1878–80

Pastel over monotype
on laid paper
(2 pieces)
40.4 × 50.5 cm
Museum of Art,
Rhode Island School
of Design, Providence.
Gift of Mrs. Murray S.
Danforth (42.213)
[L 476]

27

ployed by pastellists, particularly for portraiture.[24] In an early work executed around 1869, the portrait of his sister, *Mme Edmondo Morbilli* (fig. 8), a variety of these traditional pastel techniques is used to create a sensitive, yet formal painting of Thérèse Morbilli. The portrait reminds us of a work by Degas's hero, Ingres – *Countess d'Haussonville* (1845; Frick Collection). Not only are the two works related in composition, but Degas's early technique also typifies earlier tendencies to render a highly finished surface, exemplifying the degree to which pastel can be made to emulate an oil painting. It is indeed reminiscent of the work of earlier pastellists, such as de La Tour (see fig. 3).[25]

By the 1870s, Degas had already demonstrated considerable interest in technical experimentation, possessing "a consuming fascination with invention and process," as Druick and Zegers have noted.[26] He began to use pastel, gouache, and distemper to colour the faint second impressions of monotypes. (Monotype is the process of taking an impression of a drawing made with greasy printer's ink on a metal plate.) These opaque media, of optimum covering power, allowed him sometimes to build the prints into more elaborate compositions, often effectively masking the presence of the monotype base (see figs. 9 and 10). Many monotype passages glimmer through the strokes of pastel in *Dancer Onstage with a Bouquet*, that skip over the surface of the support, leaving highlights. The Rhode Island version (fig. 10) has only just been recently identified as a cognate. That monotype is printed on a larger support, and is effectively masked in the composition by its placement in the middle ground, framed by the woman with a fan in the lower-right foreground.

In these early mixed-media works, it is often difficult to distinguish between the various media.[27] Degas had already begun to use "wet" pastel methods; he alternately worked with a moistened pastel stick, or made a *pastel à l'eau* (by pulverizing the sticks and adding water), that was then applied with a brush.[28] The pastel paste is, of course, extremely friable or crumbly, because it contains little binder. Gouache, too, has the same matte appearance,

but the incorporation of significantly more binder with the pigment renders it more solid. Distemper, formed by mixing powdered pigment with a heated solution of water and glue, is also inherently more stable than pastel paste.[29]

By working the surface first with pastel, applied in the conventional method, Degas could then add to or modify the underlying design with gouache and distemper. The initial pastel layer had to be well stumped in order to take these layers. These media, unlike the fragile pastel paste, could continue to take more layers of colour. Finally, pastel paste or more strokes of colour from a stick could be added with little alteration to the underlying layers. One cannot ignore the physical evidence that these early experiments were not altogether successful, as a number of pastels (and other works in opaque media) over monotypes have suffered from flaking.[30]

The notebooks also attest to Degas's passion for constant experimentation with the techniques and materials of his craft. In one instance he describes a "*pastel-savon*" (or pastel "soap"), "a mixture of pastel pigments dispersed in water, with glycerine and soda [sodium carbonate]..." There is no further evidence that he actually concocted the recipe and used it.[31]

Dancers in the Wings (c. 1880; fig. 11), combines both classical pastel application with a complex mixture of gouache, distemper, *peinture à l'essence*, and pastel paste.[32] The laid paper provides airy highlights in the dancers' skirts, where it is visible through the loose strokes of pastel. Yet these passages bear traces of further handling, where the pastel has been selectively moistened – by steaming, or by spraying with boiling water – and extended with a brush (see fig. 11a). Rouart's observations bear this out: "He took great care not to spray the water vapour all over his picture, so as to give variety. He would not treat the flesh of the dancer in exactly the same way as her tutu, or the scenery might be given a different quality from the floor."[33] Distemper has been most probably used in the flooring and in the delineation of the stage flats, which may be conjectured as a deliberate merge of subject and media.

Degas's pastel technique evolves to hatched, interpenetrating lay-

29

11
Degas
Dancers in the Wings
c. 1880

Pastel, gouache, and
distemper on laid
paper (10 pieces)
66.7 × 47.3 cm
Norton Simon Art
Foundation,
Pasadena [L 585]

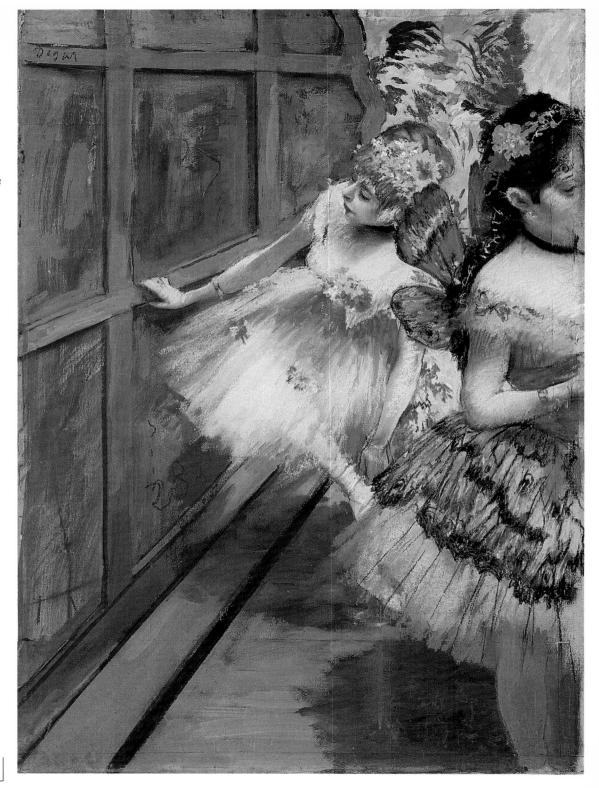

11a
Detail from *Dancers in the Wings*. This detail illustrates Degas's manipulation of the pastel surface with a brush, after it has been steamed or sprayed.

12a
Detail from *Woman Having Her Hair Combed*. A close-up of the effect of *hachures*, and the rich texture that results from this technique.

31

ers of alternating hues, evident in works like *Woman Having Her Hair Combed* (fig. 12) and *Woman with a Towel* (fig. 13). According to Rouart, Degas takes to this method after 1880, on account of his failing eyesight. The squiggles, striations, *zebrures* (a favourite "striping" device in the late pastels), and prominent crisscross *hachures* build up a richness of texture, form, and shadow, challenging our perception of "natural" colour as against "arbitrary" colour (see detail of *Woman Having Her Hair Combed*, fig. 12a).[34] The texture is remarkably more vigorous than in the early works, with strokes of bright colour creating an intense network.

Degas rarely dated his pastels. If the chronology of techniques as outlined by Rouart and the examples that he uses to illustrate them are to be believed, Degas did not employ fixative until he began to produce the dazzling late works, comprised of complicated layers of colour. There is, however, evidence to the contrary. Some of the pastel works *en hachure* incorporate fixative in their makeup, pointing to the probability that either Degas was using fixative at an earlier date than originally thought, or the pastels that Rouart has identified as employing the earlier technique of *hachures* are in fact later works.

The natural progression from juxtaposing coloured strokes to building up more complex layers of shimmering texture is exemplified in the late pastels. This practice of building images with successive layers of fixed medium – of varnishing the penultimate layer of his design with fixative, and finishing it with a final layer of unfixed pastel – is an innovation that Rouart attributes solely to Degas, yet is in fact described in technical literature from the mid-nineteenth century.[35] It is here that Degas's use of fixative (a "secret" formula that purportedly did not adversely affect the velvety quality of the pastels with undesirable surface gloss, nor alter the colours) as a medium in itself, creates a chromatic intensity and brilliance that was unprecedented.[36]

The dazzling multiple layers were applied either in networks of hatching or in parallel strokes, as in the late work, *Woman Drying Her Hair* (fig. 14). The composition is built up of strokes of pastel,

creating a network where underlying colours are visible through subsequently applied colours (see fig. 14a, detail of *Woman Drying Her Hair*). The strokes are swift and wide, often made broadside with the whole pastel stick. By moving in, out, and around the contours, the pastel tentatively defines the abstracted shape of the woman. Moreover, the vigorous action of towelling is made very real by these bursts of forceful strokes.

Degas's intermittent use of fixative to isolate juxtaposed and superimposed layers of colour, and thus prevent blending and smudging, served the secondary purpose of providing a roughened surface to which each successive layer of pastel readily adhered. This would have been necessary because tracing paper, with its typically smooth finish, has never been advocated as a pastel support. Is it therefore possible to speculate that Degas resorted, in at least one instance (according to Renoir), to a more desperate means of crushing the pastel into the support – by placing a drawing on the ground, covering it with a board, and stamping on it with his feet?[37]

Degas's habit of sometimes burnishing the pastel surface, to effect a more intimate bonding of each new pastel layer to the layers below, forced the medium into the interstices of the support and created "hollows" with each successive layer of pastel application. This resulted in the cratered or pitted surfaces typical of the multi-layer pastels. Another late work, dating from c. 1895–1900, *Dancers*, from the Princeton University Art Museum (fig. 15), is a particularly fine example of the effect of dappled colour formed by these craters (see fig. 15a, detail of *Dancers*).[38]

Attempts to identify Degas's secret fixative have met with limited success. The fixative that he used was evidently effective. Moreau-Nélaton recalls that, in order to demonstrate how successfully the charcoal and pastel adhered to the tracing paper support, Degas rubbed his finger over the pastel surface of a work he had brought to Lézin to be mounted, without any ill effects.[39] One researcher has found evidence plausible enough to conclude tentatively that Degas's fixative may have been based on casein.[40] Experiments

12
Degas
Woman Having Her Hair Combed c. 1885

Pastel on grey wove paper mounted on blue paper
74 × 63 cm
Metropolitan Museum of Art (29.100.35)
[L 847]

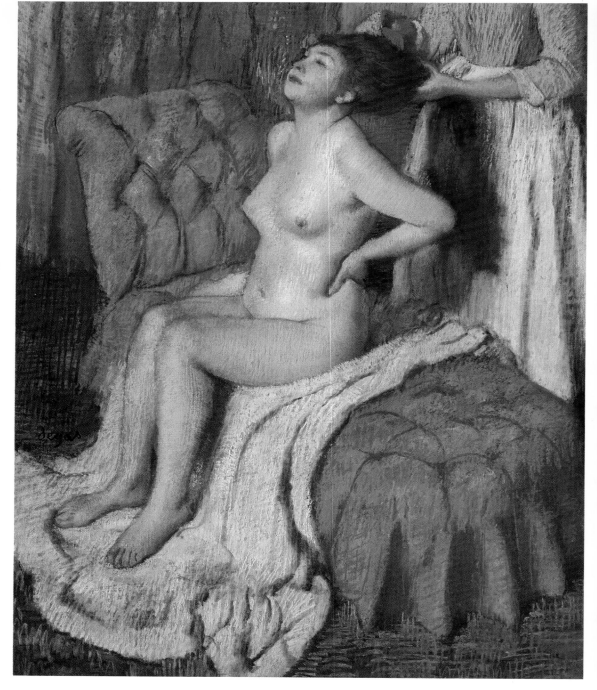

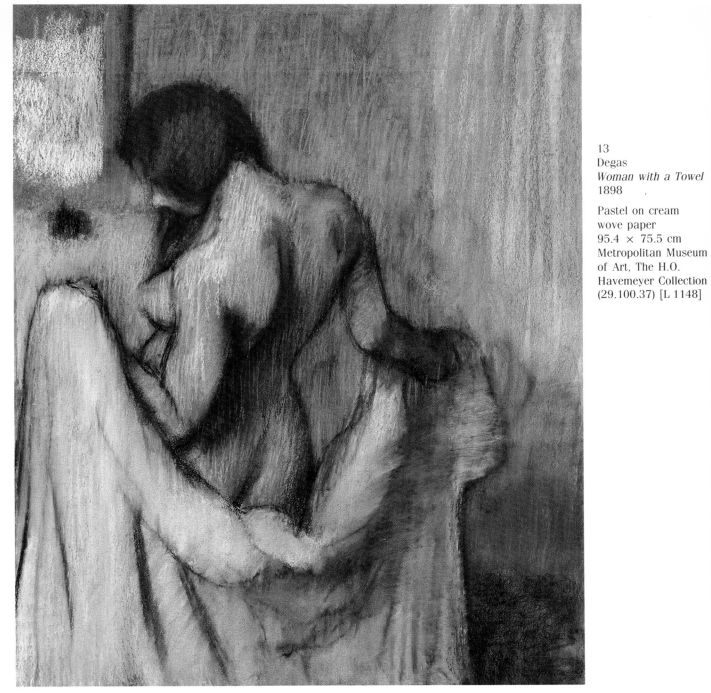

13
Degas
Woman with a Towel
1898

Pastel on cream
wove paper
95.4 × 75.5 cm
Metropolitan Museum
of Art, The H.O.
Havemeyer Collection
(29.100.37) [L 1148]

14
Degas
*Woman Drying Her
Hair* 1905–07

Pastel on wove paper
(3 pieces)
71.1 × 62.2 cm
Norton Simon Art
Foundation,
Pasadena (M.69.6.D)
[L 1454]

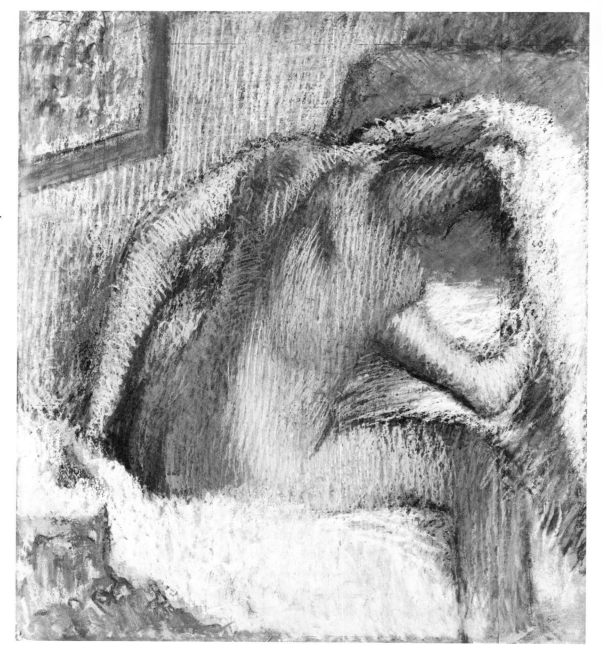

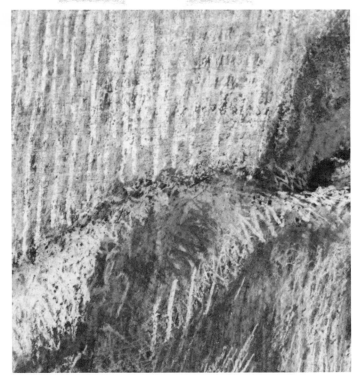

14a
Detail from *Woman Drying Her Hair*, of interlayered parallel pastel strokes.

conducted on mock-ups do indeed support this hypothesis, because the casein fixative tested did not alter the pastel surface as much as a fixative based on fish glue did. However, samples of pigments from Degas pastels at the National Gallery of Canada have been found to contain a resinous medium.[41] It is of course entirely possible that Degas experimented with more than one type of fixative formulation before the "ideal" one was divulged to him by his friend Luigi Chialiva (1842–1914).

By the 1890s, Degas had almost completely abandoned oil painting. Aside from the fact that pastel was more direct, and the pastel crayon easier for him to manipulate than oils and brushes, this system of juxtaposed tonalities intermittently layered with fixative, allowed him to simulate the transparency he admired in superimposed oil glazes.[42]

15
Degas
Dancers 1895–1900

Pastel on tracing
paper mounted on
wove paper
58.8 × 46.3 cm
The Art Museum,
Princeton University,
bequest of Henry K.
Dick (54-13) [L 1312]

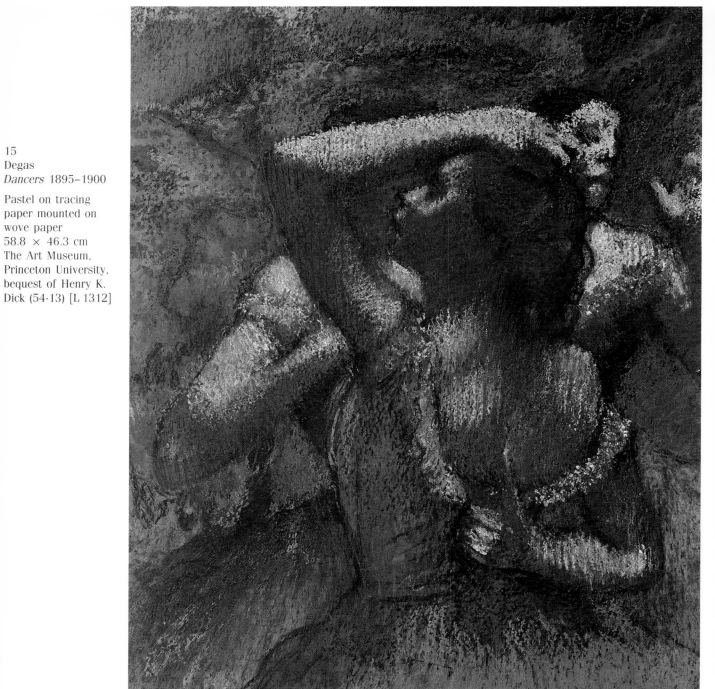

15a
Detail from *Dancers*.
The effect of the
dappled, crater-like
surface typical of the
multi-layered pastels.

4

Degas's Colours

The physical makeup of pastel has varied little since its appearance in the fifteenth century. Fabricated coloured chalks are made up of pulverized pigments combined with a base, typically of white chalk, and mixed into a paste. After the addition of a glutinous binder, like gum tragacanth (and sometimes milk, beer, ale, or fish glue in early recipes), the material is rolled into small cylinders or other shapes and left to dry. Depending upon the hardness of the pastel, it could be made to emulate the smooth nature of oil paint, by using soft pastels, or be made to achieve an effect more closely resembling drawing, with hard, gritty sticks.

The colour range of pastels available to early *pastellistes* was small, limited to palettes of earth tones and the more fugitive organic colours, encountered in sets of pastels commercially available for still-life, landscape, and portraiture. By Degas's time, pastel manufacturers were able to offer artists a more expanded and colourful palette, thanks to the discovery of the first synthetic aniline dyestuff in 1856.[43] The new technology of dyestuffs no doubt also greatly impacted the cloth-dyeing industry. Degas recognized that the brilliant, high-keyed costumes observed on stage, under the drastic effect of recently invented artificial lighting, were best depicted with the matte, reflective brilliance of pastel and other opaque media. That Degas was searching out these vibrant new subjects and motifs to further challenge his colour repertory has been suggested.[44] Degas's predilection for brighter colours developed as he increasingly worked almost exclusively with pastel.

Although valued for their richness and brilliance in colour, the organic coal-tar dyestuffs were from the outset regarded as notoriously unstable.[45] Manuals and treatises cautioned artists about

pastels "of good consistency and of brilliant tones, but which fade on exposure to light."[46] According to Ernest Rouart, Degas used pastels given to him by Chialiva that were "both vivid and light-fast."[47] Moreover, Degas was no doubt aware of the fugitive nature of these colourants. We may conclude that Degas, by placing his pastels in the sun in order to bleach the colour out of them, sought to remove all traces of fugitive colourants. Degas goes on to state that the vivid colour of his pastels is achieved with "the neutral tone" – presumably because of his "deadened colours."[48]

Pastel manufacturers have likewise been long aware of the fugitive properties of the aniline dyestuffs and organic lake pigments. The tests conducted on the current products of manufacturers in the nineteenth century prove that even the most expensive products with the greatest claims to permanence do, particularly in the case of these colours, suffer alteration after prolonged exposure to light.[49]

Regardless of Degas's attempts to mute the brilliance of his pastel sticks, a few works have still suffered alteration due to the chemical instability of their medium. There have doubtlessly been inherent colour changes in the pastel works, particularly those containing a high-key violet colour.[50]

It is very probable that Degas bought his pastels from one of the reputable *maisons de pastels* in Paris. Descendants of one of the oldest manufacturers, Henri Roché, have claimed that Degas bought from their grandfather at the turn of the century. This is borne out by the particular quality of the firm's pastels (harder than others), and the distinctive intensity of their colours (more vivid than those of Sennelier or Girault). Some of the colours that Degas almost certainly included in his palette are no longer manufactured at Roché, but appear in the samples of colours produced at the turn of the century.[51]

5

Pastel Supports

The complexity of Degas's use of pastel is paralleled by that of the supports on which we find them.

Degas worked on a variety of papers throughout his career, ranging from coarse, pumice-surfaced papers specially prepared for pastel use,[52] to the smooth tracing paper on which the majority of his late works are executed. It would seem that Degas deliberately chose his supports for their various qualities, and the colour of many of the supports upon which we find pastel studies of dancers and *café concert* singers was an integral component of the artist's intention.

The papers Degas most frequently worked on were an "Ingres"-variety laid paper, and a thin tracing paper that he had mounted on an auxiliary support. Even the most superficial study reveals these supports have altered over time: the tendency of the "Ingres" paper was to fade and lose its original colour, and that of the tracing paper was to yellow and darken.

The veined or mottled Ingres-variety laid paper was especially favoured by Degas. (Michallet was a frequent choice.) This type of paper was traditionally promoted for work in charcoal, crayon, and pastel, on account of its colours and "tooth" (roughness). By the time Degas started working with pastel, it was no longer necessary for artists to prepare their own papers by coating them to augment the surface roughness with pulverized pumice, sawdust, or sand, dispersed and adhered to the surface with, for example, gelatin or varnish.[53] There is evidence, however, that Degas chose in some circumstances to roughen the surface of his sheet before using pastel.[54]

The Ingres-variety paper was generally a hand- or machine-made, deckle-edge sheet with watermark, produced from cotton or flax.

The mottled effect was achieved by the incorporation of specially dyed fibres. These colours were obtained through dyeing, in either organic or synthetic organic (aniline) colouring matters.

Like the pastels themselves, these papers had limited light-fastness (because of fugitive colourants incorporated into them), and they have discoloured. Light-fastness tests were performed on the modern equivalents of the coloured "Ingres" papers to graphically record the rate and degree of change in the paper's colour. Within the first month, tablets were so drained of their original colour that it was impossible to ascertain the original colour without recourse to the control samples. During the following three months of exposure, the changes were less dramatic: fading continued, but at a slower rate.[55]

From the results of these accelerated light-fastness tests on "Ingres" papers of modern manufacture, we may form a hypothesis about Degas's drawings on similar papers. The considerable discolouration often encountered suggests that his supports probably lost a great deal of their original colour within a short period after their initial exposure to light – whether in the artist's studio, or in the windows or on the walls of dealers, private collectors, and public institutions.

Tracing paper (*papier calque* or *végétal*) is the type of support most frequently used by Degas for his pastels, particularly after 1890. Tracing paper was commercially available in sheets of varying dimensions, and as early as 1865 in rolls. The model Alice Michel recalls seeing rolls of paper in Degas's studio.[56] The paper was manufactured at various specialized plants in Paris and environs. In general, nineteenth-century tracing paper consisted of highly fibrillated cellulosic fibres, either flax or hemp, saturated with a mixture of gums, oils, and resins to render it translucent.[57]

The paper's translucency allowed Degas to trace and retrace the particularly large subjects, initially a corrective but later an innovative method of drawing that Chialiva introduced him to in the 1890s. Chialiva employed the paper in the process of correcting some drawings by his son, an architectural student at the École des Beaux-

Arts. Perhaps of more significance is that Degas may have been introduced to Chialiva's special fixative during a visit to his studio, where Chialiva had just fixed the tracings and was hanging them to dry on the wall.[58]

As the notebooks attest, Degas's familiarity with tracing paper dates back to his formative years. He had been using tracing paper long before his visit to Chialiva's studio; small ink drawings on tracing paper appear in some of his notebooks dating from the period between October 1856 and July 1857.[59] That Degas was already making composite drawings from more than one piece of tracing paper is validated by a drawing in another notebook, actually made up of two elements on separate pieces of tracing paper, pasted side-by-side.[60]

Several visitors to Degas's studio commented on his routine of pinning the tracing paper studies to cardboard, positioned on an easel, to be further worked in pastel.[61] Vollard, for example, commented, "He took great pains with the composition of the paper he used for pastel; however, by the very method of his work (tracing after tracing), most of his pastels were of necessity done on tracing paper."[62]

Many of the supports on which we find pastels consist of a complex assemblage of several pieces of paper, ranging from substantial additions to those adding only a few millimetres. Who in fact constructed them? The precise manner in which the various components of certain early supports were pasted down – neatly abutting each other – reflects an experienced hand that could have been Degas's. Yet it seems certain that towards the end of Degas's career, when he was almost exclusively working on tracing paper, he assigned to a professional mounter (*colleur*) the tasks both of mounting the thin paper on a more rigid support, and of either adding to or subtracting from the primary support of his works-in-progress. This is suggested by the directives in Degas's hand found on many of the pastels on tracing paper,[63] as well as by Moreau-Nélaton's recollection of having accompanied Degas to Père Lézin on the Rue Guénegaud. There Degas unrolled a pastel

16
Degas
Dancers in the Wings
c. 1880

Norton Simon Art
Foundation,
Pasadena
The white lines
indicate the pieces of
laid paper that make
up the support.

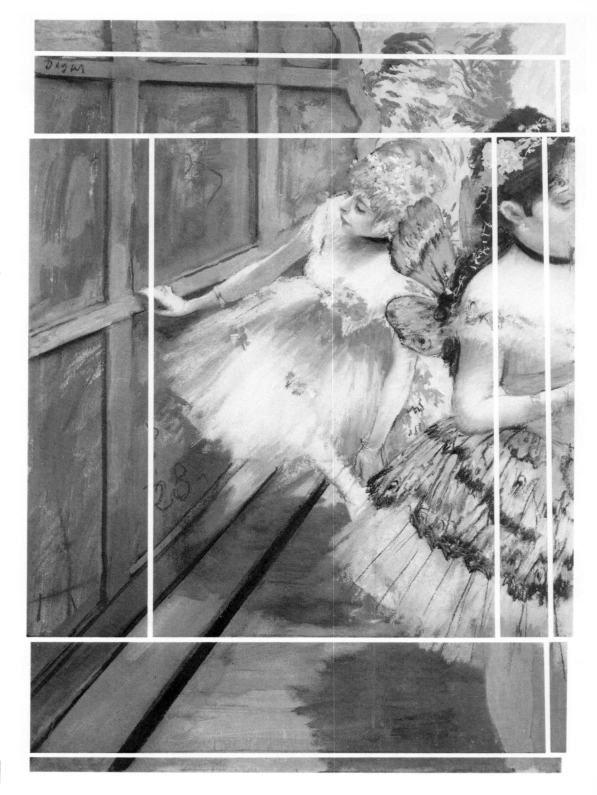

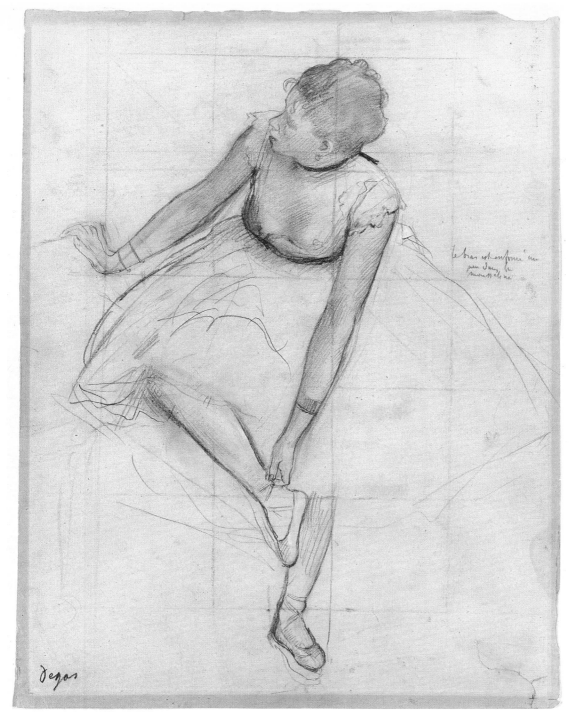

Degas

Dancer Adjusting Her Slipper c. 1874

17
Degas
*Dancer Adjusting Her
Slipper* c. 1874

Graphite and
charcoal heightened
with white chalk on
faded pink paper
33 × 24 cm
Metropolitan Museum
of Art, bequest of
Mrs. H.O. Havemeyer,
The H.O. Havemeyer
Collection (29.100.941)

on tracing paper and discussed with Lézin the adjustments to be made to the dimensions of the sheet when laying it down onto a bristol-board support.[64]

The pastels on tracing paper have likewise been affected by alterations in their support. Since nineteenth-century tracing paper was not bright white, Degas sought to impart greater brightness to his drawing by having it laid down on white bristol board, or similar boards, with white paper facings. However, the tendency of the tracing paper to yellow was inherent in the process of its manufacture. Further darkening was no doubt hastened both by the effects of the adhesive used in the mounting process, and by those of the fixative applied to its surface. It would seem then, that in Degas's pastels on tracing paper, the colours originally interacted more brilliantly with the support than they do today.

The possibility of adding to or subtracting from the primary support was doubtless of great attraction to an artist like Degas, given his tendency to rethink – and rework – his compositions. While his obsession is documented in many states of certain prints made in the 1870s and early 1890s, comparable evidence of changes in pastel is obscured in the final work. Visual examination aided by techniques such as infrared reflectography can sometimes reveal ideas that were subsequently discarded.

Helpful, too, is the close study of the way in which the composite supports of the more complex pastels are assembled. In *Dancers in the Wings*, the support consists of ten pieces of paper of varying dimensions: laidlines run horizontally *and* vertically, the pieces pasted down on an auxiliary support in puzzle fashion. By analysing the work in its component parts (see fig. 16), we can detect clues of its origin that elude us when we concentrate on the whole. When the figure leaning against the stage flat found in the composition's innermost rectangle is thus isolated from the rest of the composition, a key aspect of the composition's genesis becomes clear. The figure derives directly from a drawing of a dancer adjusting her slipper (see fig. 17), in turn the source of a figure that Degas included in a painting entitled *Dancers Resting* (fig. 18), both dated 1874.

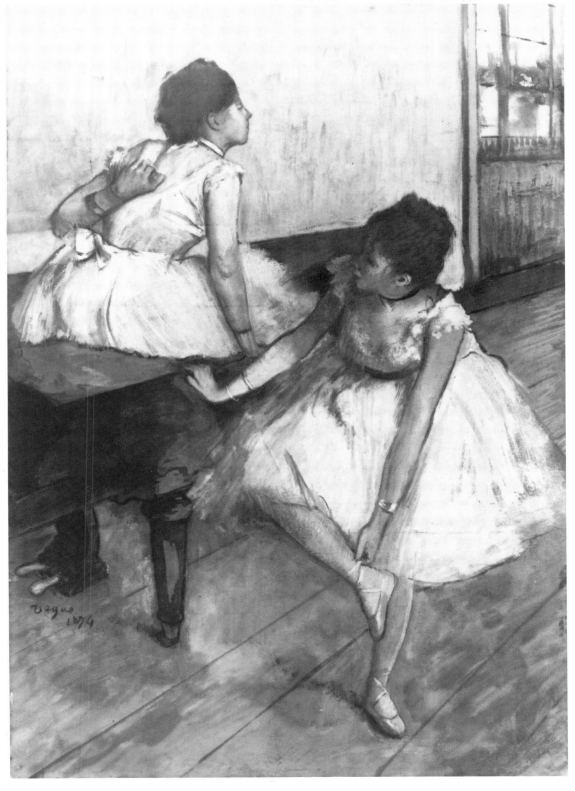

18
Degas
Dancers Resting
c. 1874

Peinture à l'essence
on paper mounted on
canvas
46 × 32 cm
Private collection
[L 343]

The same figure was initially included in Degas's famous painting *Dance Class*, then was painted over.

The fact that Degas employed the figure again in *Dancers in the Wings* has – until recently – passed unnoticed; not because, as in the Jeu de Paume painting, she is buried under a layer of medium, but because she has become lost in her new context.[65] More than a decade later, Degas would make use of tracing paper as an expedient and direct means of re-using such stock figures, tracing them from one composition for re-use in another, as we will see in the evolution of *Racehorses*, at the National Gallery of Canada.

6

Degas Pastels at the National Gallery of Canada

The National Gallery of Canada is fortunate to have in its collection a number of works by Degas, ranging from two oil paintings to several monotypes and prints, three pastels, and a charcoal drawing. The three pastels: *Racehorses* (1895–1900; fig. 30), *Dancers at the Bar* (c. 1900; fig. 22), *Dancers* (c. 1890; fig. 26), and the large preparatory charcoal drawing *The Breakfast after the Bath* (c. 1880s; fig. 19) provide the nucleus for the present discussion of Degas's working method in the making of a pastel painting. The results of their thorough examination and technical analysis have helped to corroborate and substantiate the information gleaned from the examination of Degas pastels in many other collections.

All of the pastel works by Degas in the Ottawa collection are later works, dated variously between 1890 and 1900. The time-span is admittedly short, excluding examples of early works, and the media represented are restricted to pastel and charcoal. One must bear in mind, however, that the genesis of their varying subjects preoccupied Degas for years, and that he returned to them time and again. That our works *do* represent a diversity of manipulation, complexity of stages of execution, and degree of finish – from a simple charcoal sketch to a highly-finished pastel painting – allows us to chart the manner and progression of Degas's working method.

Degas almost invariably began with a line drawing, usually in charcoal, smudging and stumping it to give volume and form to the compositional elements, and thus creating a monochromatic base to be embellished in varying degrees with pastel. This was the case for practically every pastel examined (including the pastels

19
Degas
*The Breakfast after
the Bath* c. 1880s

Charcoal on tracing
paper
109.5 × 80.6 cm
National Gallery of
Canada (18770)
(Vente III: 295)

examined in other collections); a few differed only in that brown and grey pastel were sometimes also used for this preliminary underdrawing. In fact, as much as one third of Degas's work in pastel is thought to be executed over monotype bases, another means of providing a monochromatic starting point.[66]

Our drawing, *The Breakfast after the Bath* (fig. 19), is executed on a single large piece of tracing paper, laid down onto bristol board, which is in turn attached to thick grey cardboard. The drawing was executed prior to mounting. The charcoal strokes that extend to

the edges of the support are covered by brown paper strips that were later added to bind the perimeter. The surfaces of both the bristol board and the dense grey cardboard are smooth, yet the charcoal strokes exhibit a rough, textured quality, resulting from the initially rough working surface that Degas used when he began the drawing.

Degas's practice of laying down the charcoal drawing onto an auxiliary support, enabling him to extend the measurements of his working surface (if he so desired) by adding strips of paper, no doubt also effectively fixed the drawing to some extent. Essentially, this process of mounting the drawing created a counterproof, or a reversed image of the same drawing. Some of the charcoal would have been removed from the surface in a type of transfer process, leaving only those particles most firmly adhered to and embedded in the interstices of the support, with a particular "sunken" quality. When the pasted drawing was laid on its auxiliary support, the surface was smoothed to effect contact. An interleaf of another sheet of paper would have been placed over the drawing to prevent its smudging, and in the process a counterproof could have been produced, to be further embellished with pastel if he so desired.

Counterproofs presented Degas with yet another means for revising and modifying his work. By deliberately moistening a charcoal drawing, placing another sheet over the surface, and passing it through a press, he created the same effect as when mounting the drawings. The charcoal of the original drawing would exhibit the same sunken quality as the mounted drawings, with the medium pushed into irregular clumpings by the effect of moisture. The reversed drawing would consist of a faint silvery-grey image of transferred charcoal particles.

The vertical dimension of the charcoal drawing corresponds exactly to the width of a roll of tracing paper that was advertised in a French trade catalogue of 1894. The availability of tracing paper of these dimensions made it possible to trace and retrace large subjects, such as the woman portrayed in the Ottawa drawing. The existence of two other closely-related works bears this out (see figs. 20 and 21). The unfinished charcoal drawing (fig. 21) is more boldly

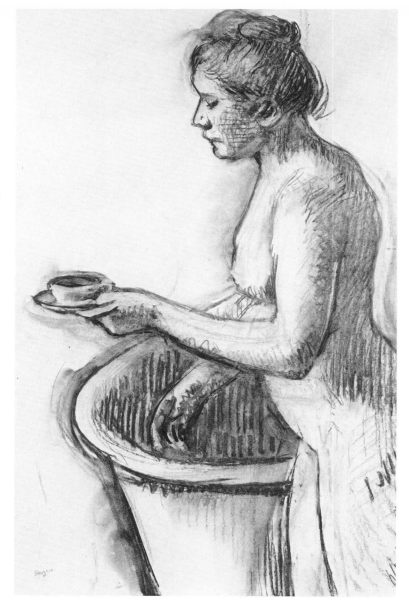

20
Degas
Study for the Maid in
"The Cup of Tea"

Charcoal on tracing
paper
110 × 60 cm
Lefevre Gallery,
London [L 725]

executed and is distinguished by design changes in the woman's
hair and in the tilt of her teacup. The somewhat larger proportions
of the figure may be explained by Degas's practice of tracing
underlying compositions by drawing *outside* their boundaries. If
Degas did indeed use the Ottawa drawing as a starting point, it is
interesting to note that he proceeded to trace an unclothed subject,
using the lines of her stomach and legs, which are only lightly
suggested in the Ottawa version.

In the highly-finished pastel painting, the maid is incorporated
into a larger composition. The vertical dimension of the main piece

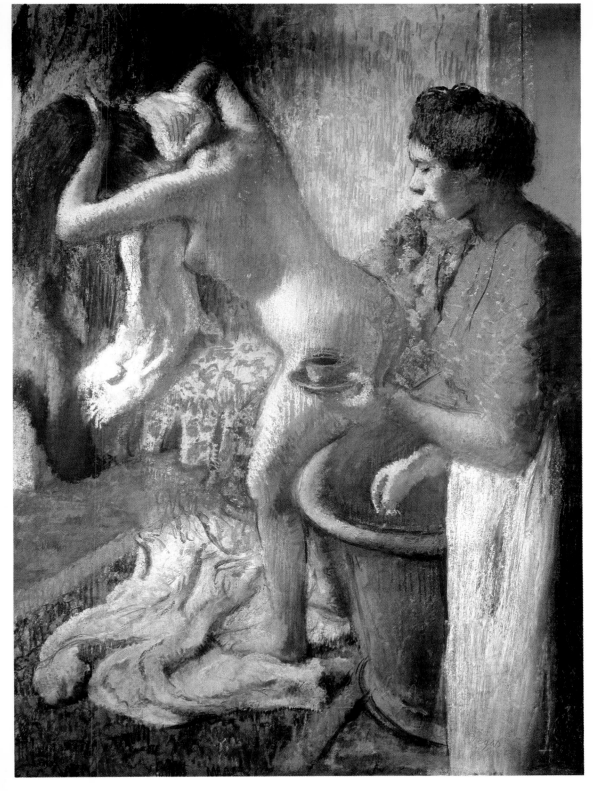

21
Degas
The Breakfast after the Bath c. 1883

Pastel on tracing paper
121 × 92 cm
Private collection
[L 724]

22a
Detail of vertical
skipping mark in
Dancers at the Bar,
and of rough-textured
pastel application.

of tracing paper in the painting corresponds closely to the Ottawa drawing, but the horizontal dimension of the sheet is longer, and the bottom of the overall support has been extended by a strip of tracing paper, increasing the measurement by approximately twelve centimetres in each direction. By varying the size of the tracing-paper support, shifting it during the tracing process, and by sometimes employing more than one compositional element from his stockpile of drawings, Degas could effectively build new works with these operations.

Dancers at the Bar The next work, *Dancers at the Bar* (fig. 22), is a charcoal drawing heightened with pastel, and left in an unfinished state. The pastel was in the studio at the time of Degas's death, and was sold in the first sale of its contents.[67]

Degas also executed several other drawings of the partially-hidden dancer on the left (see figs. 23 and 24) as studies in themselves.[68] There also exists a finished oil painting of almost identical dimensions at the Phillips Collection (fig. 25) that relates directly to the National Gallery's dancers. The unfinished state of the pastel drawing allows us the opportunity of studying the underdrawing, which, once

22b
Detail of curdled,
fixed portions
of the charcoal
underdrawing from
Dancers at the Bar.

covered with pastel (or in the case of the Phillips dancers, with oil paint), is no longer visible, or sometimes visible to a limited extent with analytical techniques such as infrared reflectography.[69]

The progression of these dancers from their unclothed state to the finished painting has been described by Jean Sutherland Boggs:

The works of Degas's late years do seem populated by ghosts – dancers with frail, insubstantial bodies and fierce souls revealed by a brilliant, warm and uncanny light. Their figures, like the drawing of the nude [fig. 23] seem to have been originally conceived as possessing some flesh, a certain strength and energy.... By the stage of the drawing in Ottawa, that body seems to have little existence aside from the forceful strokes of Degas's pastel: it is these alone which give the work its vitality and strength. By the finished oil [fig. 25] she is even further removed from the descriptive – her leg elongated, her profile simplified, her back a rich play of colour and light. And apathy has triumphed; the sense of a concerned mind within the dancer has disappeared.[70]

Because the dimensions of these works correspond so closely to the National Gallery's dancer, it is probable that they are in fact

22
Degas
Dancers at the Bar
c. 1900

Pastel and charcoal
on tracing paper
(2 pieces)
111.2 × 95.6 cm
National Gallery of
Canada (1826)
[L 808]

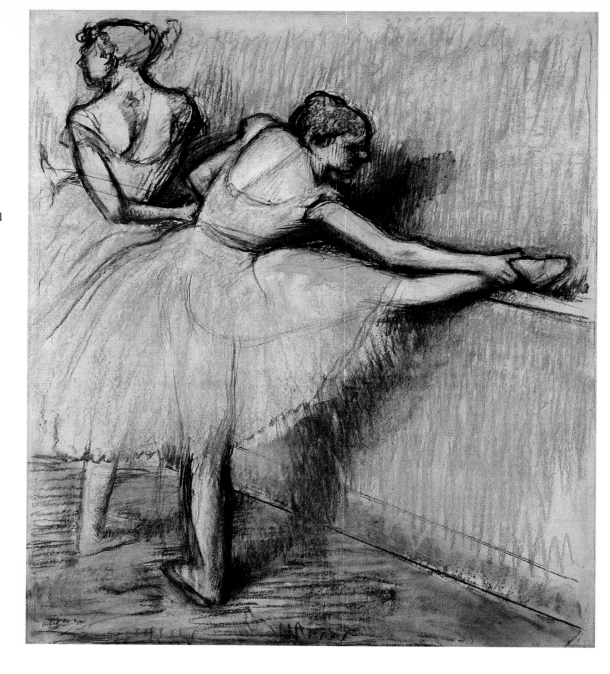

22c
Detail of steamed pastel in the dancer's skirt in *Dancers at the Bar*.

22d
Detail of the effect of drawing into the charcoal with a wet brush, and of erasure in the pastel.

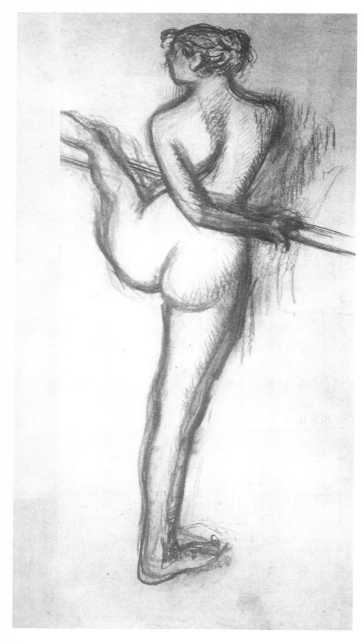

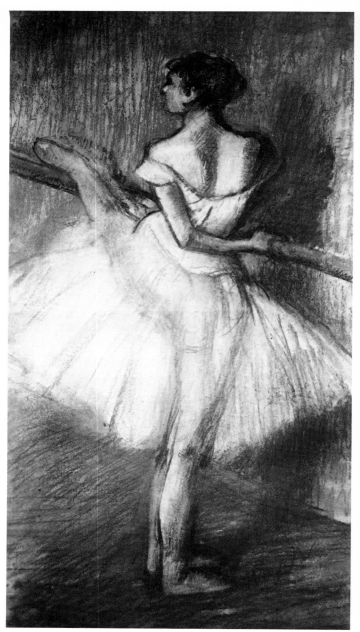

23
Degas
*Dancer Exercising at
the Bar* c. 1900

Charcoal on tracing
paper
110.2 × 58.1 cm
Location unknown
(Vente I: 332)

24
Degas
Dancer at the Bar
c. 1900

Charcoal and pastel
on tracing paper
110.2 × 62 cm
Location unknown
[L 811]

60

tracings.[71] The support of one of the works (fig. 23) is extended along the left side by two added pieces of paper, but the drawing does not extend onto them.

The vertical dimension of the support for *Dancers at the Bar* has been extended by a mere nine millimetres with an added strip of tracing paper along the top edge. Graphite notations in the upper-left corner, partially erased, can be construed as directives for extending the support, and have frequently been observed on other pastels that have been closely examined.

The vertical skipping mark through the dancer's head, top left (fig. 22a) indicates that the Ottawa drawing and some of the preliminary colouring were executed before the drawing was mounted. The rough, bumpy texture of strokes of the red sienna of the dancer's hair resembles the effect already noted in *The Breakfast after the Bath*, of working on an irregular surface prior to mounting.

The surface of *Dancers at the Bar* has been heavily fixed, and appears shiny when examined under raking light, in areas where the surface has not been subsequently worked with pastel. The fixative has in fact left small, glistening circles on the pastel surface, and has ''curdled'' portions of the exposed charcoal drawing, causing the charcoal to spread into irregular patterns, because of the force of spraying the surface at close range (fig. 22b).

It is of great interest to note that pastel strokes have been applied *over* some of the fixed areas. The National Gallery pastel is in fact the only one examined closely that bears unequivocal evidence of the nature of Degas's fixative in the preliminary stages of the execution of a pastel, and that in no way can be confused with a fixative layer applied by a later hand.[72]

A variety of manipulations of pastel may be observed throughout the composition. The most significant of these is the possible evidence of the use of steam to fix the vaporous blue of the dancers' skirts. Small, matte, saturated points of blue dot the surface (fig. 22c), unlike the shiny spray of fixative. Degas has nimbly suggested the hem of the dancer's skirt by extending the charcoal with a wet brush, and has echoed this effect, in negative, by drawing into the smudged pastel of the baseboard with an eraser (fig. 22d).

25
Degas
Dancers at the Bar
c. 1900

Peinture à l'essence
on canvas
130.1 × 97.7 cm
Phillips Collection,
Washington [L 807]

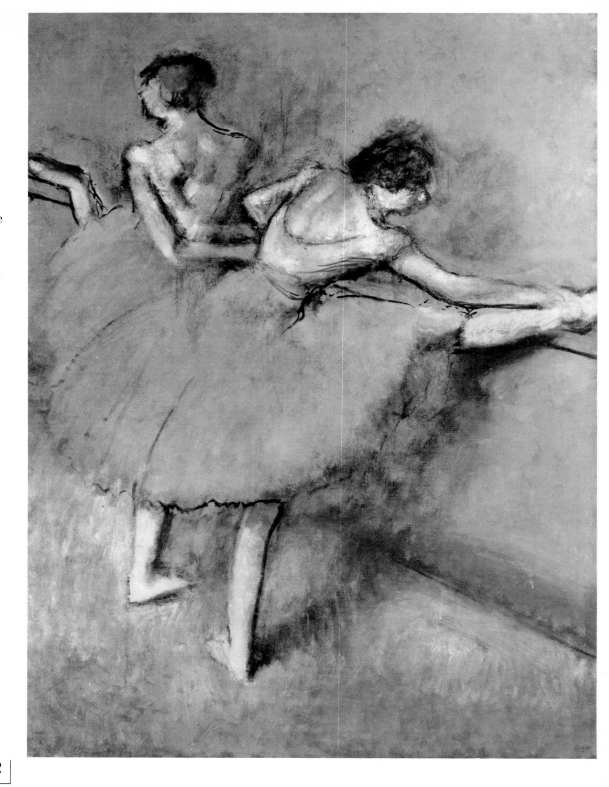

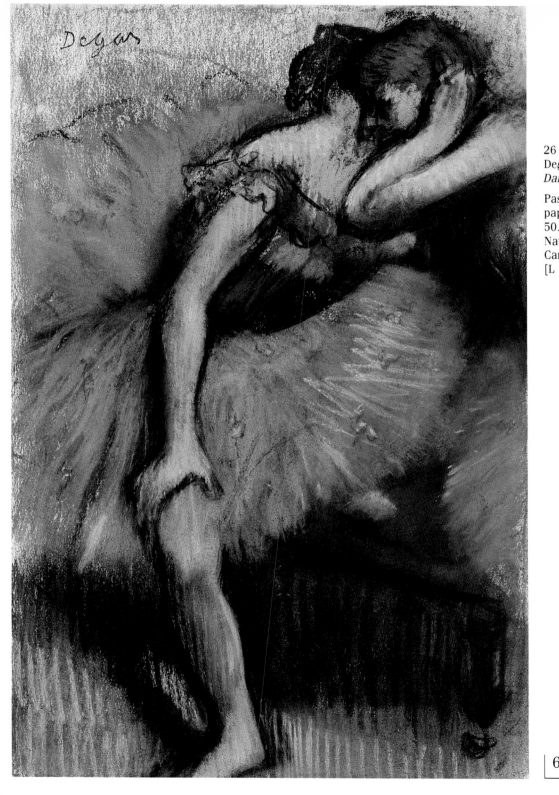

26
Degas
Dancers c. 1890

Pastel on white wove
paper
50.1 × 32.5 cm
National Gallery of
Canada (6090)
[L 1103]

The formation of small, raised blisters scattered throughout the support often signals the presence of tracing paper, such as in *Dancers at the Bar*, even though the support may appear at times to be much more substantial. It follows that with the application of moisture to mounted tracing paper, be it in the form of steam to fix the layers of friable colour, or by working into the pastel and charcoal with a moistened brush, the tracing paper may potentially be released from its auxiliary support.

Dancers The pastel, *Dancers* (fig. 26), displays an increasing degree of finish. Signed in the upper-left corner in black chalk,[73] the pastel is applied to a rough-textured white wove paper initially in a straightforward manner, in broad strokes using the side of the stick, allowing the texture of the paper to read through the colour layer as dappled highlights. Smudging and stumping their green skirts and solid limbs, Degas gives substance to the dancers. More laboured, thicker layers of colour have been applied in a paste-like consistency to add more voluminous layers of different colours of green to their skirts. Pinkish-red stains on the verso of the support correspond to the most heavily-worked part of the drawing, the bench under the main dancer's raised leg, attesting to the use of moisture.

The dancers' skirts are made even more full and vaporous by the brushed touches of moistened pastel. Hachures of white pastel clearly define the shadows of the dancer's leg and the end of the void beneath the bench on which they rest. Their forms, the details in their dresses, and their hair are described by the strong, final strokes of charcoal.

Degas did many studies of figures in these attitudes (see figs. 27, 28, 29) – mostly on tracing paper – that are closely related to *Dancers*. All of these figures share a strained repose, a weary anonymity, so commonly encountered in Degas's late works. Yet the brilliant, if somewhat blurred quality of the luscious green pastel of the Ottawa dancers is stimulating.

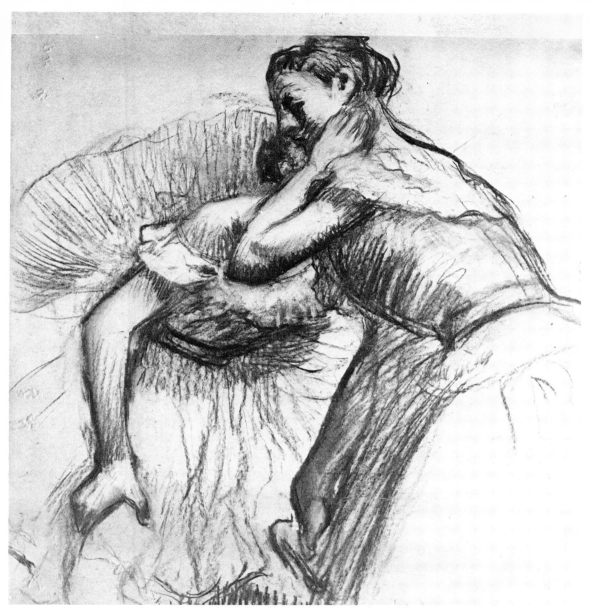

27
Degas
Two Dancers Resting
1890–95

Charcoal on tracing
paper
51.1 × 47.5 cm
Philadelphia Museum
of Art (63.181.144)
(Vente II: 288)

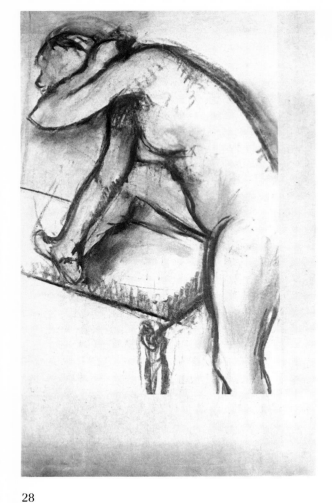

28
Degas
Study of a Dancer
c. 1890

Charcoal on tracing
paper
52 × 34 cm
Location unknown
(Vente IV: 184)

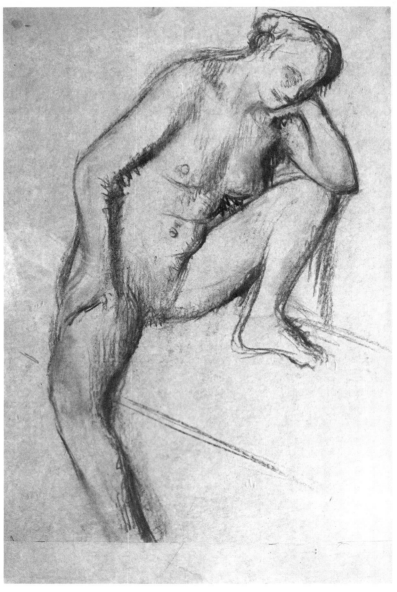

29
Degas
Study of a Dancer
c. 1890

Charcoal on tracing
paper
61 × 42 cm
Location unknown
(Vente III: 274)

30b
Detail from
Racehorses of the
outlining of the
extreme left jockey's
boot.

Racehorses The final work, *Racehorses* (fig. 30), is a fully-realized pastel paint-
ing, complete with what are construed to be Degas's obsessive
retouches in the sky (fig. 30a). The rich and complex textural array
of colour is a thick, impasto-like buildup of intermittently fixed layers
and layers of colour.

This pastel is an excellent example of Degas's later working
method: he used fixative at intermediary stages – which accounts
for the many glossy areas that can be seen below the top layer
of pastel throughout the design. The ultimate pastel layer is not
fixed, and typically the design elements are redefined in a last stage
of simple outlining with pastel, operating as a uniting factor in the
composition. This is well illustrated in the quick strokes of Prussian
blue outlining the boot of the jockey on the extreme left (fig. 30b).

The tracing-paper support is solidly laid down onto wove paper,
and is extended by an added strip along the bottom edge. Again
it clearly serves the function of allowing Degas the ease of replicat-
ing and modifying his composition, as witnessed by the existence
of two other versions of the racehorses, varying only by a few mil-
limetres in external dimension.

Four Jockeys (fig. 31), dated 1883–85, is the simplest of the three
versions in terms of pastel application. Executed on a single piece
of tracing paper, the preliminary charcoal drawing is still highly
visible, and has been slightly smudged to define the forms of the
horses. The pastel is worked in simple strokes, mostly within the

67

30a
Detail from
Racehorses of
retouches in wet
pastel applied with a
brush around the
jockeys' heads.

confines of the charcoal, with smudging limited to the sky and parts
of the horses' bodies. Degas considered this a finished work, as
it is signed in the lower-right corner in black chalk.

From this point, the evolution of the related works most proba-
bly followed this scenario: Degas traced the Rhode Island jockeys
and reversed the composition, thus creating the Cleveland version
(fig. 32). He then raised the horizon in the picture plane (by cutting
off the top portion of sky in the Rhode Island jockeys), and added
a strip of tracing paper to the bottom of the new composition to
accommodate the change. When the Rhode Island jockeys are
reversed, and the two compositions are superimposed, the figures
of the two jockeys on the left fall almost directly in line, even to
the slightly slumped stance of the jockey riding out of the picture
frame. The positions of the background jockeys are slightly modi-
fied, with the distance between the second and third notably
increased, and the foliage behind the Cleveland jockeys has added
a lush texture to the countryside.

As with the Ottawa jockeys, the Cleveland composition is a more
fully realized pastel painting, with the support almost entirely

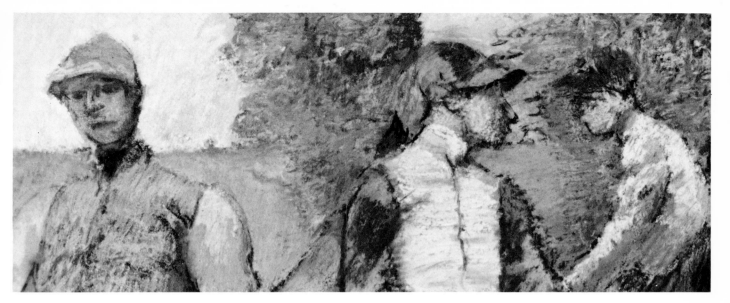

32a
Detail from the
Cleveland *Racehorses*
of the jockeys' heads.

covered with complex layers of intermittently fixed pastel. The rich
networks of pastel hatchings weave in and out of the horses and
jockeys and the background. Volumes are defined and shapes are
solidified by a final outline in dark colours. Degas then returns to
the composition with dashes and flicks of brilliant hues of orange
and blue.

In the final version, the Ottawa jockeys now loom closer to the
foreground, their forms traced and swollen to fill the picture plane.
Their faces are abstracted; their distinguishing features obliterat-
ed by complex layers of pastel.[74] (Compare figs. 30a and 32a.) The
horse in the centre of the composition has changed its stance and
moves in a blurred profile. The pastel application is loose, more
thickly applied in the glowing silks of orange, yellow, and
ultramarine blue. The scumbled areas of grey-green behind the
jockeys' heads seem to be applied in a dilute pastel paste form,
softening and obscuring changes Degas may have made to their
positions. When compared to its distant cousin in Rhode Island,
the Ottawa pastel shines forth with a vigour and energy in execution.

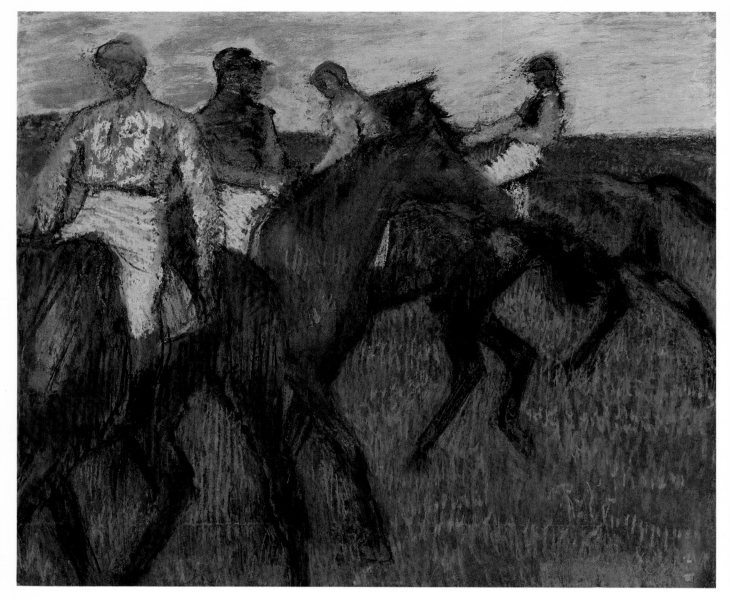

30
Degas
Racehorses
1895–1900

Pastel on tracing
paper (2 pieces)
55.6 × 64.1 cm
National Gallery of
Canada (5771)
[L 756]

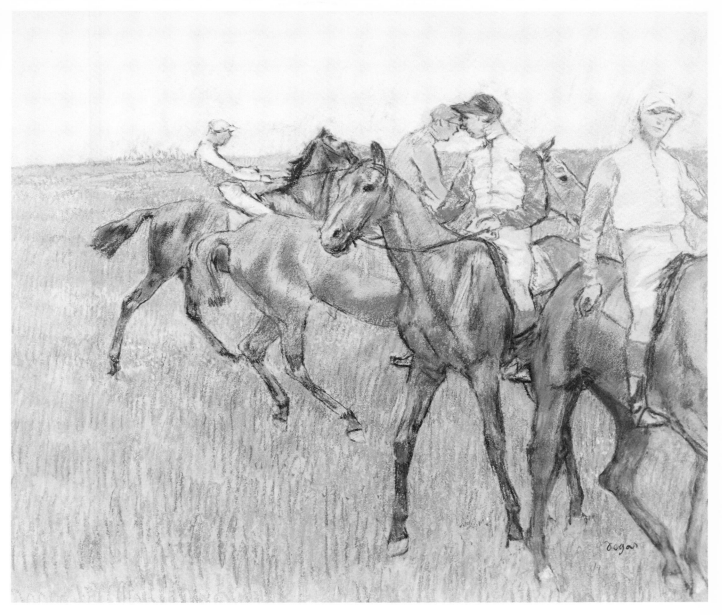

31
Degas
Four Jockeys
1883–85

Pastel and charcoal
on tracing paper
56 × 64 cm
Museum of Art,
Rhode Island School
of Design, Providence.
Bequest of George
Pierce Metcalf
(57.233) [L 757]

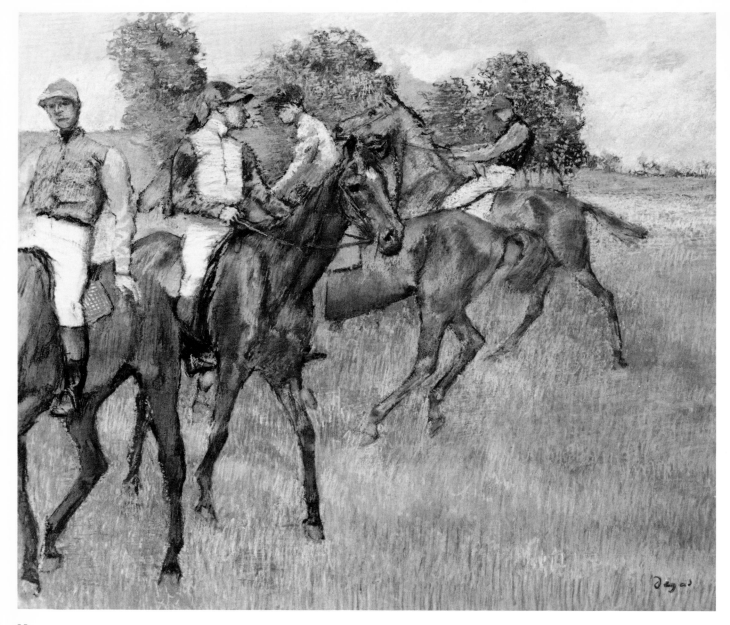

32
Degas
Racehorses 1883–85

Pastel on tracing
paper (2 pieces)
55.5 × 64.4 cm
Cleveland Museum of
Art. Bequest of
Leonard C. Hanna, Jr.
(58.27) [L 755]

7

Conclusion

In the course of our research, we have gathered information on wide-ranging aspects of Degas and pastel. From our review of eighteenth- and nineteenth-century pastel treatises, visits to French pastel manufacturers, and scrutiny of the evolving attitude towards pastel over the nineteenth century, we have been able to define the sources – both in a historical context and in a contemporaneous one – of Degas's precursors and of his own initial attraction to the pastel medium. Most importantly, the detailed examination of a significant number of unframed pastels in both public and private collections has provided invaluable insight into Degas's pastel technique and the supports he employed. We have been able to confidently assess the accuracy of information about the artist's habits by authors who have claimed direct or at least second-hand knowledge. Of these, Denis Rouart has proved to be generally reliable in his straight observations on technique. He, in turn, has been the source for countless other references to Degas's pastel technique. However, one cannot set store by Rouart's chronological context for dating Degas's works solely on the basis of technical evolution.

Study of Degas's pastel technique and the supports he employed makes it possible to begin to address the difficult question of "finish" in the artist's late work. The moment Degas had his preliminary drawing in charcoal and pastel on tracing paper laid down on a rigid auxiliary support, he apparently made a definite decision on the desired format. Thereafter, in developing his work, the artist seems to have made no alterations to the dimensions of the support. Thus, when we find a pastel on a primary support of tracing paper, that has been enlarged with additional strips of paper – on which there is no evidence of medium – we can conclude that the work

marks an early stage of evolution. It appears that Degas made the decision to develop a drawing further on tracing paper, took it to a professional such as Lézin to prepare it for subsequent embellishment, but then did not carry out his intentions.

The results of close examination of a number of Degas's late pastels have also made it possible to challenge the question of the fragility and perishability of the pastel medium. The thick, impasto-like layers that are formed by the buildup of alternating strata of pastel and fixative appear to be much more stable than the conventional pastel. Even the ultimate, unfixed layer of these late pastels is effectively adhered to the surface by the underlying fixative, and in this sense Degas's pastel paintings depart radically from the physical makeup, and vulnerability, of pastels executed in more conventional techniques.

Ageing experiments with materials similar to those that Degas used have revealed some interesting results. As a consequence, when studying Degas's work, we must always bear in mind that in varying degrees – depending on the nature of the work and its history – both media and support have changed, and thus the artist's original intention has been obscured. In certain instances, the changes have been so great as virtually to disqualify the work from Degas's oeuvre.

What differentiates Degas's use of the pastel medium from that of his predecessors and contemporaries is not so much *what* he did as the *extent* to which he did it. Degas ingeniously combined the medium with distemper and gouache. He used a number of layers of medium to realize the most developed of his late pastels, and employed fixative as a medium in itself to realize novel textures and effects. In short, Degas transformed traditional practice into a new expressive vehicle.

Finally, our study has led us to new levels of appreciation for Degas's pastels, not only as consummate works of art but as telling reflections of the artist's personality. While pastel was traditionally promoted to aspiring novices as an easy medium to handle, it was to Degas the perfectly suitable vehicle for expressing his

complex artist's temperament. The works communicate both the feverish pace at which Degas's mind raced and the impatience he suffered at the inability of his hand to keep up. The pastels are often eloquent reflections of the conflict between the artist's awesome dexterity and his even greater intellectual capacities.

Notes

1. We are indebted to Debora D. Mayer for making available to us her bibliography on pastel treatises and manuals at the initial stages of our research. See also Victoria Blyth, "Electrostatic Stabilizing Plate (ESP): An Alternative Method for Stabilizing the Flaking Tendencies of Works of Art in Pastel," *AIC Preprint*, Spring 1978, pp. 21–29; Debra Daly, *An Investigation into the Use of Several Substances as Fixatives for Works of Art in Pastel*, Qualifying Paper, Queen's University, Kingston, Ont., 1978; and Françoise Flieder, "Study of the Conservation of Pastels," *Science and Technology in the Service of Conservation*, IIC Preprints, Washington, 1982, pp. 71–74.

2. Folio 247, *Codex Atlanticus*, Milan, Biblioteca Ambrosiana, ed. J. Meder, *Die Handzeichnung*, Vienna, 1923, p. 136. Leonardo da Vinci was first introduced to pastel by Jean Perréal, a French artist who accompanied Louis XII to Milan in 1499.

3. Many *pastellistes* of the eighteenth century shared Degas's passion to find an acceptable process for fixing pastel. See, for example, a chronology of attempts to find a fixative for pastel painting in "La Tour," *Gazette des Beaux-Arts*, 1 April 1867, 3ᵉ liv., n. 1, p. 369. De La Tour (1704–1788), purportedly discovered a "varnish" that did not alter the pastel surface. L'Abbé Le Blanc, "Lettre sur l'Exposition des ouvrages de peinture, à Monsieur R.D.R.," 1747. Among others, M. de Saint-Michel, painter to the King of Sardinia, claimed to have found a fixative that did not alter the pastel surface; he offered his secret to the first thousand subscribers who paid three *louis* for a book of his famous recipes. The Prince of San Severo claimed to have found the ultimate fixative, based on "colle de poisson" (fish glue). The best fixative is purportedly the one invented by Loriot, reported to the Académie de Peinture in 1756, but not published until 1780. The early treatise, *Traité de la peinture au pastel*, by M.P.R. de C., Paris, 1788, gave precise instructions for preparing and applying fixative. Recipes were closely-guarded, proprietary secrets; even in the late nineteenth century, artists were still searching for the perfect fixative. Degas's secret fixative, formulated by his close friend Luigi Chialiva, was never divulged. See also Ratouis de Limay, *Les pastels du XVIIᵉ et XVIIIᵉ siècle*, Paris, 1925.

4. Geneviève Monnier, *Le Pastel*, Geneva, 1983.

5. Letter to M. d'Angivillier, 1778. *Chardin et M. d'Angivillier; correspondance inédite de l'artiste et de sa femme avec le directeur général des bâtiments du roi*, ed. Marc Furcy-Raynaud, Paris, 1900, p. 31.

6. For a discussion of Chardin's work in pastel, see Suzanne Folds McCullagh and Pierre Rosenberg, "The Supreme Triumph of the Old Painter: Chardin's Final Work in Pastel," *Museum Studies*, The Art Institute of Chicago, Vol. 12, No. 1, Fall 1985, pp. 43–59.

7. Charles Desmaze, "La Tour," *L'Artiste*, 15 August 1853, p. 129.

8. The category of "Les Aquarelles, Pastels, Dessins, etc." first appears in the Salon of 1835.

9. Camille Flers, "Du pastel; de son application au paysage en particulier,"*L'Artiste*, 23 August 1846, pp. 113–116. Flers assesses the relative merits of pastel and oil painting.

10. See Jerry Reynolds Nelson, *The Pastel Technique of Jean-François Millet and its Influence on his Style*, a qualifying paper submitted to the faculty of the Institute of Fine Arts, Graduate School of Arts and Sciences, New York University, October 1984.

11. Druick and Zegers identify the popularity of the opaque media with artists of the 1870s, including Degas. For a detailed discussion, see their essay, "Scientific Realism: 1874–1881," in exhibition catalogue, *Degas*, Ottawa: National Gallery of Canada (co-publication), 1988.

12. See Druick and Zegers's essay in *Degas*, 1988, for a discussion of Degas's attitude towards his art during this period.

13. Research by Druick and Zegers indicates a decline in the number of works in oil exhibited between 1876 and 1881; in this period, Degas painted no more than 75 paintings, but produced more than 250 works in pastel, gouache, and distemper, including mixed media works and those on a monotype base. See also Denis Rouart, *Degas à la recherche de sa technique*, Paris: Floury, 1945, p. 16.

14. Druick and Zegers list these as contributing factors to Degas's initial interest in the opaque media in their essay in *Degas*, 1988. A private exhibition of the Nittis pastels in the Cercle de la Place Vendôme in 1881 received a great deal of attention. See Alfred de Lostalot, "Les pastels de M. de Nittis au Cercle de l'Union Artistique," *Gazette des Beaux-Arts*, Vol. 24, 1881, pp. 156–165.

15. See the essay by Druick and Zegers, "Degas and the Printed Image: 1856–1914; Part II: The Peintre-Graveur as Peintre-Entrepreneur, 1875–80," in Sue Welsh Reed and Barbara Stern Shapiro, *Edgar Degas: The Painter as Printmaker*, Boston, Museum of Fine Arts, 1984, pp. xxviii–lv.

16. Jacques-Émile Blanche, "Notes sur la peinture moderne," *Revue de Paris*, 1913, in R.H. Ives Gammell, *The Shop Talk of Edgar Degas*, Boston: 1961, p. 22. Also Paul Lafond, *Degas*, Vol. 1, 1918, p. 20.

17. Christopher Lloyd and Richard Thomson, *Impressionist Drawings from British Public and Private Collections*, Oxford, 1986, p. 15. See this publication for a more detailed discussion of the role that Degas played in influencing the drawing habits of the Impressionists.

18. See Anthea Callen, *Techniques of the Impressionists*, Secaucus, N.J.: Chartwell Books, Inc., 1982, pp. 22–25.

19. Georges Jeanniot, "Souvenirs sur Degas," *La Revue Universelle*, LV, 15 October 1933, p. 167.

20. See Theodore Reff, "The Technical Aspects of Degas's Art," *Metropolitan Museum Journal*, Vol. 4, 1971, pp. 141–166. Contradictions in Degas's attitude towards his craft are noted; Degas lamented the loss of technical know-how, but he retained an irreverence for materials and procedures that led

to the unfortunate condition of many of his works in various media. See also Notebook 31 (1878–79), in Reff, *The Notebooks of Edgar Degas*, Vol. 1, Oxford: Clarendon Press, 1976, p. 67 and Denis Rouart, pp. 10–12.

21. See Druick and Zegers's essay in *Degas*, 1988.

22. The appearance of the resulting medium is also matte and chalky, though of a different quality than the other opaque media.

23. Denis Rouart. See, for example, Douglas Cooper, *Pastels by Edgar Degas*, New York, 1953; Alfred Werner, *Degas Pastels*, London, 1969; Bernard Dunstan, "The Pastel Techniques of Edgar Degas," *American Artist*, Vol. 36, No. 362; George Shackelford, *Degas: The Dancers*, Washington: National Gallery of Art, 1984, pp. 109–127; David Chandler, "Edgar Degas in the Collection of the Art Institute of Chicago: an Examination of Selected Pastels," in *Degas: Form and Space*, Paris: Centre culturel du Marais, 1984, pp. 443–448; and Shelley Fletcher "Two Monotype Pastels by Degas at the National Gallery of Art, Washington," in *Degas: Form and Space*, pp. 450–451; Pia De Santis, *An Examination of the Degas Pastels at the Fogg Art Museum*, unpublished research project, Center for Conservation and Technical Studies, Harvard University, July 1984.

24. Early treatises on pastel include Sir William Sanderson, *Graphice, Use of Pen and Pensil*, London, 1658, pp. 77–81; John Russell, *Elements of Painting with Crayons*, Dublin, 1773; and Raphael Mengs, *The Art of Pastel Painting*, 17–, translated by Henry Leidel, New York, 1885.

25. The pastel medium struggled in the seventeenth and eighteenth centuries to establish its credentials against oil paint; the tendency was to use pastel to imitate the effects achieved with oils.

26. Druick and Zegers's essay, "Degas and the Printed Image, 1856–1914," in Reed and Shapiro, pp. xv–lxxii.

27. See Denis Rouart's discussion of mixed media and the uncertainty of accurate identification, pp. 17–22.

28. S. Jozan, *Du Pastel – Traité de sa composition, de son emploi dans la peinture, et des moyens propres à la fixer...*, Paris, 1847, outlines a recipe for making a "gouache" from pastel moistened with a diluted varnish, to be used for retouches.

29. Sometimes pastel paste is observed to have a granular quality, containing small particles of pastel. Layers of thickly-applied gouache occasionally contain minute, frothy bubbles. The usage of distemper then current was more craft-oriented; relegated to the theatre world, it continued to be used for painting stage sets, as it had been for centuries. The only distinguishing characteristic of distemper is the appearance of a "tidemark" sometimes surrounding a painted area, thought to be the glue medium. Analytical methods may shed more light on medium identification; this is possible only when a sample of appropriate size is available for analysis.

30. Cracking and subsequent flaking and loss of opaque medium (be it pastel paste, gouache, or distemper) have been observed in some of the early pastels over monotype examined. It is entirely possible that the flaking may be related to the inherently oily character of the underlying monotype; however, in most cases the pastel is executed over the lightly-inked second pull. The bulk of the ink would

have been discharged from the plate when the first impression was pulled. In order for the subsequent layers of wet medium to adhere, the initial pastel layer would have to be well stumped into the support. Otherwise the paint would eventually separate from the powdery surface of the pastel.

31. Notebook 33, usage in Paris 1879–82; p. 3, verso.

32. See Denis Rouart's observations on this work, p. 18. Rouart claims that Degas sprayed boiling water on the surface of the pastels then worked into it with a brush. Experiments have indicated that the water does not have to be boiling in order to solubilize the pastel. Conversely, steaming did little to render the pastel more easily brushed out.

33. Denis Rouart, p. 22.

34. One of the works described as *"hachure"* of this period is in the collection of the Fogg Art Museum: *La sortie du bain*. Detailed examination of this pastel has revealed the presence of fixative (Pia De Santis research). *Après le bain* [L 1148], at the Metropolitan Museum of Art, is one of the few pastels dated by Degas (1898). Although it too appears to have been executed *en hachure*, there is evidence that intermittent layers of fixative separate the layers of colour.

35. S. Jozan, *Du Pastel...*, Paris, 1847. In the context of Jozan's treatise, it is very interesting to note that retouching is advocated *after* the surface of the pastel has been fixed, in order to restore the brightness to the light colours: "redonner ... quelques touches dans les clairs, pour leur rendre tout leur éclat," p. 69. The insinuation is that even Jozan's method of fixing dulls the colours. An interesting note on the reworking of pastel after it had been revarnished appears in the publication by Renou, secretary of the Académie royale de peinture, in 1780, concerning the discovery of the ideal fixative by Loriot. In Loriot's own opinion, some works of "very great masters" could not be fixed by this method (of misting the surface of the pastel with fixative), either because they had been prepared with pumice *or because the sketch had been varnished and then reworked*. See M.P.R. de C., *Traité de la peinture au pastel*, Paris, 1788.

36. Ambroise Vollard reports that Degas refused to use commercial fixatives, and used instead the one that Chialiva formulated. Vollard, *Degas: An Intimate Portrait*, New York: Dover Publications, 1986, p. 68 [originally published in French as *En écoutant Cézanne, Degas, Renoir*, Paris: Grasset, 1938, p. 122].

37. Jeanne Baudot, *Renoir: Ses amis, ses modèles*, Paris: Éditions littéraires de France, 1949.

38. When examined under magnification, these small craters sometimes appear to be shiny, resinous deposits, probably a discoloured fixative layer. Communication with Roy Perkinson, Conservator, Museum of Fine Arts, Boston, 1984.

39. Étienne Moreau-Nélaton, "Deux heures avec Degas – interview posthume," *L'Amour de l'Art*, July 1931, No. 7, p. 269. The pastel drawing that Degas would have brought to be mounted would probably have been in the initial stages of execution – and therefore heavily fixed. It follows that Degas would not have been easily able to disturb the pastel layer of such a drawing.

40. Pia De Santis, July 1984. She reports some reasons why Degas may have used a casein fixative. De Santis cites Denis Rouart's claim that Degas admired the effects that the paint-

er John Lewis Brown achieved with casein. In addition, she has found preliminary evidence that Degas may have used a fixative/medium containing casein in samples of pigments taken from Degas pastels at the Fogg Art Museum, analysed with the fluorescing antibody technique.

41. One must consider that it is virtually impossible to distinguish between the binder used in the pastels themselves and the type of fixative used, with the current available methods of analysis. It is also possible that Degas may have experimented with more than one type of fixative, hence the detection of both casein and a resinous material in different Degas pastels.

42. Denis Rouart, p. 34.

43. Sir William Perkin discovered "Perkin's mauve" in England in 1856. It is an artificial organic dyestuff, and comes in the form of reddish-violet crystals. The colour, when applied, is dull violet. Although it is fugitive, it has seen limited use as a watercolour. See the entry in Gettens and Stout, *Painting Materials: A Short Encyclopedia*, New York, 1966, p. 130.

44. Richard Kendall, "Degas's Colour," in *Degas 1834–1984*, ed. Richard Kendall, Manchester: Department of History and Design, Manchester Polytechnic, 1984, pp. 19–31.

45. See the Russell and Abney *Report ... on the Action of Light on Watercolours*, London, 1888. Pastels were considered to be more "permanent" than either watercolour or oil paint.

46. J.-G. Vibert, *La Science de la Peinture*, ed. Paul Ollendorf, Paris, 1891, p. 239. "On obtient des pastels d'une très bonne pâte et de tons magnifiques, mais qui s'évanouissent à la lumière." [English version from *The Science of Painting*, translated by Percy Young, London, 1915, p. 141].

47. Ernest Rouart, "Degas," *Le Point 2*, No. 1, Feb. 1937, p. 22.

48. Vollard, p. 63.

49. Current claims to permanence include this one found on the lid of a 1984 box of Sennelier pastels: "Les pastels à l'ÉCU sont fabriqués avec des pigments selectionnés pour leur stabilité à la lumière et la vivacité de leurs tons." It is difficult to find equivalents today for the most brilliant hues that Degas used; pastel manufacturers tend to stay away from pigments and dyestuffs with fugitive qualities, although the odd one is still used.

50. Pia De Santis, July 1984, reports the fading of this colour to a blue, upon loss of the fugitive red lake component, in one of the pastels at the Fogg Art Museum.

51. Information learned during visit of Druick and Zegers to various pastel manufacturers in Paris and environs, namely Sennelier (Paris and Orly), Henri Roché (Paris), and Girault (Montreuil).

52. *Femme se tenant le cou* [L 798], Fogg Art Museum, Harvard University, is executed on a rough, green-brown wove paper.

53. Jerry Nelson mentions this in her 1984 paper on Millet pastels; also Fichtenberg, *Nouveau Manuel Complet du Fabricant de Papiers de Fantaisie*, Paris, 1852. Other sources mention the roughening of the paper surface (or millboard, pasteboard, etc.) with pumice; see also Henry Murray, *The Art of Painting and Drawing in Coloured Crayons*, London, 1856.

54. *Two Dancers Entering the Stage* [L 448], Fogg Art Museum, Harvard University, and *Danseuses en Scène* [L 601], Art Institute of Chicago, are two pastels examined and found to have protruding fibres throughout the sup-

port. Degas apparently prepared the surfaces of the supports by roughening them *before* executing the pastels. The disturbed fibres do not necessarily result from the vigorous abrasive action of the pastel on the support, because they also appear in uncoloured, exposed passages. This effect is particularly well illustrated in the composition, *Two Dancers Entering the Stage*. Pia De Santis notes the roughened surface in the Fogg pastel in her unpublished research project, July 1984.

55. Tablets were exposed to both eastern and southern daylight at increments of one month for a total of four months.

56. Since Michel relates Degas's practice of drawing the same composition on several pieces of tracing paper, we may surmise that the roll described was tracing paper. Alice Michel, "Degas et son modèle," *Mercure de France*, 16 February 1919, p. 458.

57. The mixture most frequently recommended in the treatises is Canada balsam gum and turpentine.

58. J. Chialiva, "Comment Degas a changé sa technique du dessin," *Bulletin de la Société de l'Histoire de l'Art Français*, Vol. 24, 1932, pp. 44–45.

59. Notebook 8, usage in Rome, October 1856–July 1857, p. 2, a brown-ink drawing of a copy of an Etruscan mirror back, showing *Semele and Dionysus*. Noted by Reff, Vol. 1, p. 56. Notebook 18, usage in Paris and Normandy, 1859–64, also contains many drawings on tracing paper tipped into the pages of the notebook.

60. Notebook 18, usage in Paris and Normandy, 1859–64, p. 215. Copies of South Pacific figures. Reff notes that many changes and omissions were made from the illustration from which it was copied, namely L. de Freycinet, *Voyage autour du monde, Atlas Historique*, Paris, 1825, pl. 62 (Reff, Vol. 1, p. 101).

61. Michel, "Degas et son modèle," pp. 631–632; Moreau-Nélaton, "Deux heures avec Degas," p. 258. The action of pinning and repinning the tracing paper to the easel may have resulted in damage to the corners of the support. Close examination of several pastels on tracing paper has revealed the presence of small pieces of tracing paper inserted into the larger main sheet. These may be infills, replacing the support where it was torn and perforated by pinholes.

62. Vollard, p. 68.

63. See, for example, *The Dance Lesson*, Metropolitan Museum of Art, New York (1971.185) [L 450], and *Danseuses au repos*, Museum of Fine Arts, Boston (39.669) [L 661]. (Neither of these pastels is executed on tracing paper; Degas also used laid and wove papers to create assemblages.) The graphite notation on *The Dance Lesson* is located in the upper-right corner of the main sheet, partially obscured by pastel: *9c à droite / 3c en haut / un centimètre en plus de to*[us?] *côtés / pour la / feuillure*. The pieces of paper added to the top and right side of the main sheet are very close in measurement to the dimensions noted. We are indebted to Margaret Holbein Ellis, paper conservator at the Metropolitan Museum of Art, for arranging for us to view the inscription using infrared reflectography. Similarly, a graphite notation in the right-central area of the Boston pastel is partially obscured by pastel and reads: *15c à gauche / 3c en haut*. Again, the added strips closely approximate these measurements. On one pastel ex-

amined, *Femme s'essuyant après le bain* (private collection, on loan to the Art Gallery of Ontario, Toronto), a graphite inscription was written on the verso of the support, and is partially visible through the tracing paper, where it has not been covered with pastel. It is illegible.

64. Moreau-Nélaton, "Deux heures avec Degas," p. 269.

65. *Dance Class*, 1876 [L 341], Musée du Jeu de Paume, Paris. For details, see George Shackelford, pp. 46–49 and 60–61.

66. Richard Kendall reports of the significance of Degas's monochromatic bases in "Degas's Colour."

67. The work is not signed, but bears the red vente stamp from the first sale in 1917, in the lower-left corner. The pastel was bought at that time by the French dealer Jacques Seligmann, and subsequently purchased by the National Gallery of Canada from his own sale in 1921. See J.S. Boggs, "*Danseuses à la barre* by Degas," *National Gallery of Canada Bulletin*, Vol. 2, No. 1, 1964, pp. 1–9 and 29; and R.H. Hubbard, *The National Gallery of Canada Catalogue of Paintings and Sculpture, Vol. II, Modern European Schools*, Ottawa, 1959, p. 20.

68. See Paul-André Lemoisne, *Degas et son oeuvre*, 4 vols., Paris: Paul Brame and C.M. de Hauke, Arts et Métiers graphiques, 1946–49 [809, 810, 811, II Vente:262, III Vente:199].

69. David Chandler has used this technique to analyse the underdrawings of the Degas pastels at the Art Institute of Chicago. See "An Examination of the Degas Pastels at the Art Institute of Chicago," in *Degas: Form and Space*, pp. 443–448.

70. Miss Boggs discusses the extremely difficult task of dating *Danseuses à la barre* in the article "*Danseuses à la barre* by Degas," pp. 1–9 and 29.

71. It is not known whether the two related drawings of the left dancer are on tracing paper, although they appear to be in the reproductions examined.

72. Refer to the Appendix for results of technical analysis done on a sample of the fixative from this work.

73. Vollard may have encouraged Degas to sign his works.

74. Examination of the Ottawa *Jockeys* with infrared reflectography has revealed underdrawing in their faces, the features of which are not unlike the Cleveland jockeys.

Appendix: Technical Analysis of the Degas Pastels at the National Gallery of Canada

Anne F. Maheux, Judi Miller, Ian N.M. Wainwright

In the chemical analysis of Degas's pastel materials and technique, particular attention has been focussed on attempting to identify the nature of the fixative that Degas exployed to realize his complex, layered pastel paintings, such as the National Gallery of Canada's *Racehorses*. Analysis of this work, along with the Degas pastels, *Dancers at the Bar* and *Dancers* in Ottawa, was undertaken with the cooperation of the Canadian Conservation Institute (CCI).

The methods of analysis chosen are typically limited by the size of sample that can be harmlessly and inconspicuously removed from the pastels. Moreover, analytical methods were selected that could provide information about the organic constituents of the samples, such as the binder, organic colourants, and fixative, should any of these be present.

With this in mind, microscopic samples were removed from each work for chemical analysis by infrared spectroscopy, a method which, it was thought, would provide evidence of Degas's fixative formulation, and also of the pastel binder. It is noteworthy that should such a constituent be identified, it could be so similar chemically to other organic constituents as to be indistinguishable.

In the case of *Racehorses*, samples were also analyzed by means of a non-destructive x-ray spectrometric technique to assist in the interpretation of the infrared spectra and to identify the pigments. For the samples from *Dancers* and *Dancers at the Bar*, examination by polarized light microscopy was undertaken to confirm the results of infrared spectroscopy and aid in pigment identification.

Methods Fourier transform infrared (FTIR) spectra were obtained from each of the samples mounted in a diamond anvil microsample cell. Subsequently, each sample containing carbonates was treated with hydrochloric acid and a second, carbonate-free spectrum was generated. The resulting FTIR spectra were compared to published reference spectra and to spectra obtained from reference material in the CCI laboratory.

FTIR finds application in the identification of the organic chemical compounds used as artist's materials, such as gums, oils and resins, and organic pigments, lakes and dyes. It is also useful in the analysis of inorganic paint materials including many pigments, fillers, and extenders.

The chemical elements present in the immediate vicinity of the fifteen sample locations on *Racehorses* were identified using a non-destructive x-ray spectrometric technique. The technique uses an annular radioactive source (americium-241) to excite selected areas of the pastel of several millimetres in diameter. The x-rays which are in turn emitted from the area, and which are characteristic of the chemical elements present, are detected and measured with an x-ray energy spectrometer. Elements down to about calcium (atomic number 20) in the periodic table can be identified this way.

Mixtures of pigments, as so many of the samples from Degas's pastels tend to be, are clearly not resolved by this method, and the area excited by the radio-isotope source is too large to allow individual colours to be isolated. Despite these drawbacks, it is often possible to make a judicious interpretation of the x-ray spectra and to draw conclusions about which inorganic pigments, fillers, and extenders are most probably present.

Samples from *Dancers* and *Dancers at the Bar* were dispersed in Carmount, a microscopical mounting medium having a refractive index of 1.66, for examination with polarized light microscopy.

Results Tables 1, 2, and 3 outline the results of the various methods of analysis for each of the Degas pastels.

In addition, the following elements were found in the samples

analyzed by non-destructive x-ray spectrometry from *Racehorses:* barium, calcium, magnesium, lead, chromium, iron, copper, zinc, arsenic, strontium, antimony, and mercury.

The combined results of the chemical analyses indicate that the constituents making up the pastels of Degas's palette are all typical of the latter half of the nineteenth century. The bulk of the pastel is made up of various fillers, extenders, and white pigments: barium white, zinc white, lead white, chalk, china clay (kaolin), silica, and gypsum. Pigments that were found are: vermilion, iron oxide red, chrome orange (basic lead chromate), chrome yellow, lead antimonate yellow (Naples yellow), emerald green, chrome green (chrome yellow plus Prussian blue), viridian, Prussian blue, ultramarine blue, violet-coloured organic dye, and charcoal black (charcoal). Probable pigments include various ochres, siennas, umbers, and strontium yellow.

Only the infrared spectra of the samples from *Dancers at the Bar* indicate the presence of a resinous material. The fixative (or binder) may have contained a natural resin. No fixative or binder was detected in any samples from *Racehorses* or *Dancers*. The presence of starch grain fragments in samples from *Dancers at the Bar* may be traces of binder. Starch, along with various types of gum (arabic and tragacanth), are the binders most frequently mentioned in manuals and treatises on pastel manufacture. Many of the samples readily dispersed in the microscopical mounting medium during polarized microscopy, which indicates a low concentration of binder holding the pigment particles together.

Discussion The various fillers, extenders, and white pigments found in the samples point to the distinct handling properties and physical characteristics of pigments. The choice of filler depends on the pigment; these formulae have evolved into proprietary recipes guarded by the pastel manufacturer.[1]

None of the above pigments can be said to have been invented just prior to the execution of the pastels; they include pigments discovered in the eighteenth and nineteenth century, as well as those

that have been in common use for centuries. The list of pigments is undoubtedly incomplete, as the sampling was restricted to only three works, and the methods of analysis may not have detected a number of materials including organic pigments (lakes or dyes) which could be present.[2]

Our research indicates that Degas may have used a resinous fixative on the pastel *Dancers at the Bar*.[3] Given Degas's predilection for experimentation, it is not unusual to find evidence of more than one type of fixative.

There are certain limits to what can be achieved with small samples, even when experimental conditions are optimum. These depend on the nature and concentration of chemical compounds present and the degree to which the infrared spectrum – in the case of analysis by Fourier transform infrared spectroscopy – of one or more of them may interfere with the spectrum of the materials under investigation, namely any number of fixatives and binders. In spite of our attempt, with all the samples for *Racehorses*, to optimize conditions by, for example, removing interfering carbonates, no evidence of such organic materials was found. Pending further study, it can be estimated that fixatives and binders must be present in concentrations of only a few percent.

Notes to the Appendix

1. See, for example, Robert Dossie, *The Hand-maid to the Arts*, London, 1758. Dossie warns that organic pigments should not be mixed with fillers such as chalk, flake white, or white lead: these will alter the colour. Plaster of Paris and "pearl white" are recommended instead. Flake white and white lead do not mix well, and the pastels formed are too brittle (pp. 183–187). Current French pastel manufacturers who were active in the nineteenth century will not divulge specific information about the ingredients of their products.

2. The results of our work parallel the studies carried out at the Fogg Art Museum, Cambridge, Mass., of Degas's pastel pigments.

3. Preliminary work carried out at the Fogg Art Museum with the fluorescent antibody technique, which makes use of the immunological reaction between an antigen and its antibody, has indicated that Degas may have employed a casein fixative/binder. Pia De Santis, *Examination of the Degas Pastels at the Fogg Art Museum*, unpublished research project, Center for Conservation and Technical Studies, Fogg Art Museum, Harvard University, July 1984.

Table 1: *Racehorses*

Sample No.	Location	Description	Colour	FTIR compounds detected
1.	9.5 *l* × 12.0 *b*	1st jockey's shirt[1]	light orange	basic lead chromate, calcium carbonate, kaolin
2.	12.5 *l* × 12.0 *t*	1st jockey's shirt	pale yellow	calcium carbonate, kaolin
3.	8.5 *l* × 16.0 *b*	1st jockey's boot	dark blue	Prussian blue (no fillers evident)
4.	19.0 *l* × 8.8 *t*	2nd jockey's shoulder	blue	ultramarine blue (little evidence of fillers)
5	17.3 *r* × 12.5 *t*	4th jockey's arm	orange	basic lead chromate, calcium carbonate, kaolin
6.	8.5 *r* × 12.5 *b*	grass above signature	green	barium sulphate, kaolin
7.	23.0 *r* × 12.0 *b*	grass below third horse	yellow-green	lead chromate, possibly zinc oxide, an unidentified compound also in No.12
8.	20.5 *l* × 6.5 *b*	grass above seam	mocha-brown	calcium carbonate
9.	10.0 *l* × 18.0 *b*	edge of first horse	orange	kaolin, amorphous silica
10.	9.0 *l* × 12.0 *t*	1st jockey's breeches	creamy white	calcium carbonate, kaolin
11.	22.5 *l* × 17.0 *t*	2nd jockey's sleeve	orange-red	kaolin (same spectrum as No.14)
12.	16.5 *l* × 8.0 *t*	sky near 2nd jockey	grey-green	calcium carbonate, silicates, probably Prussian blue, an unidentified compound also found in No.7
13.	16.0 *l* × 11.0 *b*	1st horse's leg	brown	barium sulphate, amorphous silica, gypsum
14.	7.2 *r* × 3.2 *b*	signature	orange	kaolin (same spectrum as No.11)
15.	0.0 *r* × 11.0 *t*	sky, upper right	pale yellow	barium sulphate, calcium carbonate, silicates

[1]Jockeys and horses are numbered left to right.

Table 2: *Dancers at the Bar*

Sample No.	Location	Description	Colour	FTIR compounds detected	Polarized light microscopy
1.	16.5 *r* × 9.0 *t*	stripes, back-ground	pink	kaolin, calcium carbonate, resin	calcium carbonate, iron oxide/hydroxide red and yellow
2.	11.0 *r* × 13.5 *b*	stripes, back-ground	pink	kaolin, calcium carbonate, resin	kaolin, precipitated calcium carbonate, ultramarine blue, charcoal black, starch grain fragments, iron oxide red
3.	14.0 *r* × 0.4 *b*	bottom right	green	Prussian blue, chrome yellow, resin, kaolin, possibly a carbonate	chrome yellow, Prussian blue, yellow ochre, possibly lead antimonate yellow
4.	30.0 *r* × 0.5 *b*	bottom right	green	kaolin, resin, a cellulosic component, possibly a carbonate	calcium carbonate, chrome yellow, Prussian blue, lead antimonate yellow
5.	23.5 *r* × 12.8 *b*		red-brown	iron oxide red, calcium carbonate, resin	iron oxide red, calcium carbonate
6.	10.5 *l* × 22.0 *b*		orange	kaolin, calcium carbonate, possibly a resin	iron oxide red, iron hydroxide yellow, charcoal black, possibly lead antimonate yellow, low concentration of vehicle
7.	4.5 *l* × 56.0 *b*	skirt	blue	kaolin, resin, calcium carbonate	ultramarine blue, calcium carbonate, a vehicle
8.	11.5 *l* × 42.0 *t*	skirt	blue	kaolin, calcium carbonate, resin	ultramarine blue, charcoal black, starch grain fragments, calcium carbonate
9.	16.5 *l* × 8.5 *t*	hair, left	dark purple	possibly a carbohydrate, resin	organic dye/lake, charcoal black
10.	44.0 *l* × 18.0 *t*	hair, right	red-brown	iron oxide red, calcium carbonate, resin, a cellulosic component	iron oxide red, charcoal black, calcium carbonate
11.	40.0 *r* × 23.5 *t*	face, right	orange	lead chromate, kaolin, possibly calcium carbonate, a resin	charcoal black, chrome orange, low concentration of vehicle
12.	32.0 *l* × 10.0 *b*	dancer's leg	white	kaolin, calcium carbonate, resin	possibly kaolin, precipitated calcium carbonate
13.	27.0 *l* × 30.5 *b*		black	possibly calcium carbonate	charcoal black

Table 3: *Dancers*

Sample No.	Location	Description	Colour	FTIR compounds detected	Polarized light microscopy
1.	16.0 *r* × 9.5 *t*	neck, left dancer	pink	kaolin, calcium carbonate	iron oxide red, precipitated calcium carbonate, chrome yellow, charcoal black, quartz
2.	13.5 *r* × 11.5 *t*	neck, left dancer	pink	kaolin, calcium carbonate	kaolin, precipitated calcium carbonate, quartz, starch fragments, iron oxide red, emerald green, charcoal black
3.	9.5 *r* × 4.0 *t*	hair, right dancer	burnt sienna	iron oxide red, kaolin, chrome yellow, calcium carbonate	iron oxide/hydroxide yellow, brown, and red, charcoal black, chrome yellow
4.	15.5 *r* × 13.5 *t*	top of dancer	green	Prussian blue, chrome yellow, kaolin, possibly white lead	chrome green (chrome yellow well coated with Prussian blue), charcoal black, iron oxide red
5.	15–20.0 *r* × 0.3 *t*	top edge	light brown	kaolin, calcium carbonate, quartz, white lead	iron oxide red, precipitated calcium carbonate, quartz
6.	9.8 *r* × 18.5 *r*	toe	brown	kaolin, calcium carbonate	quartz, possibly white lead, ultramarine blue, chrome yellow, iron hydroxide yellow-brown
7.	0.5 *r* × 15.8 *b*	edge of primary support	green	Prussian blue, chrome yellow, kaolin, calcium carbonate	chrome yellow, ultramarine blue, precipitated calcium carbonate, emerald green
8.	13.0 *r* × 18.0 *b*	bench	red-brown	iron oxide red, kaolin, calcium carbonate	iron oxide red, iron hydroxide brown, chrome yellow, charcoal black, emerald green, ultramarine blue
9.	3.0 *l* × 17.5 *t*	skirt	mint green	emerald green, kaolin, calcium carbonate	emerald green, charcoal black, precipitated calcium carbonate
10.	0.5 *l* × 22.5 *t*	edge of primary support	yellow-green	Prussian blue, chrome yellow, kaolin, calcium carbonate, unidentified component	chrome yellow, chrome green (chrome yellow and Prussian blue), emerald green, charcoal black

Table 3: *Dancers*

Sample No.	Location	Description	Colour	FTIR compounds detected	Polarized light microscopy
11.	11.0 *r* × 23.3 *b*	touches to skirt	flesh-colour	iron oxide red, kaolin, possibly quartz	quartz, iron oxide orange/brown, possibly white lead
12.	3.5 *r* × 2.5 *b*	bench leg	grey-green	Prussian blue, chrome yellow, kaolin, calcium carbonate, an unidentified component	ultramarine blue, charcoal black, chrome green (chrome yellow and Prussian blue), chrome yellow, precipitated calcium carbonate